S0-BYR-449

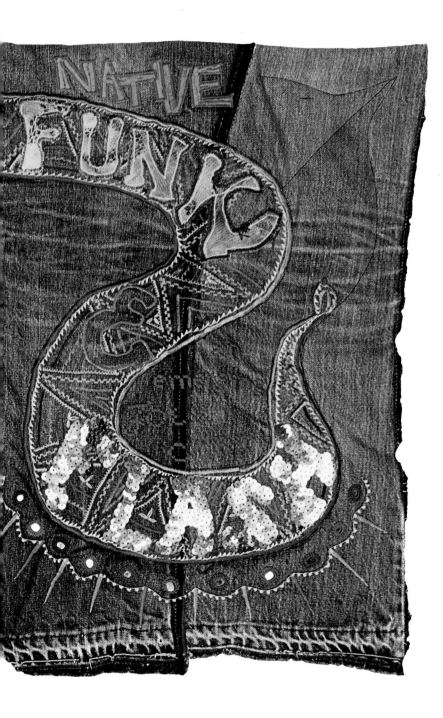

Native Funk & Flash:

An Emerging Folk Art

Alexandra Jacopetti

photographs by
Jerry Wainwright

Scrimshaw Press 1974

Library of Congress Cataloging in Publication Data

Jacopetti, Alexandra.
 Native Funk & Flash; an emerging folk art.

 1. Folk art I. Wainwright, Jerry, 1926-
illus. II. Title.
NK789.J32 1974 745'.0973 74-7073
ISBN 0-912020-37-7 ISBN 0-912020-38-5 (pbk.)

The design of this book came through the cheerfullest cooperation among
the author and photographer and Dick Schuettge, Karen Petersen,
Frederick Mitchell and Georgia George (who did the cover and dustjacket)

My friendship with Jerry Wainwright started several
years before this story begins, back about 1960. In the
years that have followed, our influence on one another,
psychically and aesthetically, has been an important plea-
sure to us both. Jerry's quiet and steady presence runs
behind the words and through the pictures of this book.
 Alexandra Jacopetti

© Copyright 1974 by Alexandra Jacopetti and Jerry Wainwright

THIS COLLECTION of contemporary folk art comes mainly from the San Francisco Bay area, but it is representative of a much more generalized return to home-decorated functional objects. It comes from my own point of view—as an observer of its emergence and development, as a folk artist, and as a participant in the culture from which it springs.

Many of us have hungered for a cultural identity strong enough to produce our own versions of the native costumes of Afghanistan or Guatemala, for a community life rich enough for us to need our own totems comparable to African or Native American masks and ritual objects.

The native funk and flash in this book tell us something of that hunger and what we are doing to fill it, as well as something of the meaning of those artifacts from other places and times. My hope is to make the consciousness behind these folk expressions more understandable and accessible to others and to stimulate people to experience for themselves the joy and fulfillment of making their own art for themselves.

MY FIRST "psychedelic patch," as I called it then, was done in 1966, after Roland and our son Hobart returned from a trip to Mount Lassen designed to strengthen the spiritual bonds of father and son. Ben (Roland was still called Ben then) had knelt on the sulfurous soil at the side of a hot spring and later, in brushing off the yellow dust, he found that it had burned right through the knee of a just-nicely-broken-in pair of Levi's jeans. "Fix them," he said plaintively. "I just had them feeling right and now they're ruined."

I had taken up embroidery not long before, as a return to things of the past which should not be forgotten, and had become excited by the wonderful things one can do with a needle. I remembered needlework at my grandmother's house, when the Relief Society ladies came for an afternoon quilting bee, at the end of an earlier era. This was Preston, Idaho, on the Utah border, around 1945, where time moved slowly. The fine crocheting, tatting and cutwork these

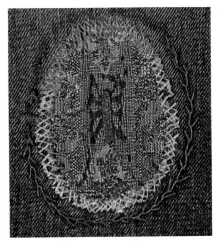

ladies turned out were a wonder to behold. You can still see them in chunks and pieces on the backs and bottoms, skirts and shawls of folks today.

Oh yes, the Levis. So I threw on a patch. I had planned a well-hidden one, with the tiny stitches and the exactly-matching fabric —almost as good as new. But, damn it, why not better than new? Why drudge when you can have fun? Out came the scraps of fancy upholstery fabrics and the colored threads. Mandala! Perfect! My, how I admired that first patch! Roland wasn't as thrilled as I was because it was a bit flashy and his clothes at that time were simple, functional and unadorned.

A denim shirt of traditional western cut had been purchased along with the Levis and was mellowing out with continued use. Denim has a way of stretching on its jeans-twill lines (over two, under one) that makes it fit comfortably and protectively and conform smoothly to your shape as it wears. It really does become your own. When I want to dress for work and not be encumbered with extra folds of cloth, fringes or gew-gaws or other bits that might catch or snag, on go the broken-in jeans—the ones that have just one patch on the knee, not the ceremonial old ones. If I just want to feel like me, not like the little woman or the professional weaver or Earth Mother, then these mellowed jeans are just the thing.

That's just how that western shirt was for Roland. The color had washed to a nice middle blue and the fabric had a certain velvety smoothness from the short soft cotton fibers that had escaped the hard first-woven web. Meanwhile, I had scored a few beautiful hand-made laces from the thrift stores and a piece or two of interestingly textured fabrics which might serve as embroidery grounds. I even scouted the new-cloth stores, watching for some of that handsome

homespunny fabric on which to embroider another mandala. I ended up with Indianhead cotton, a factory product with much less soul than unbleached muslin, which was for some reason acting hard-to-find back then.

Symbols and signs were flying around my brain those days. Spiritual talk and truck. Our family had just made its escape from the public eye, our swan song having been that great first coming-out ball, The Trips Festival at Longshoremen's Hall in San Francisco, February 1966. We watched Bill Graham get the Fillmore together, while Roland felt the need to clear out: "I've got to get away . . . I don't know—read some Zen or something." "Give it all away," was one of our catch phrases and, after giving a bunch of it away, we packed up that old Dodge panel truck with a treadle Singer (good little machine—still runs perfectly), pots and pans, a lot of brown rice and our functional clothes. We sighed our relief at finally getting out.

Morningstar Ranch was glorious for the first few weeks. The Indianhead cotton was being covered completely with "The Faithful Approach the Bread of Life" and little running stitches in shades of blue and gray were making perfectly marvelous water for the four faithful fish swimming to a yin/yang bread center. My thoughts then began to turn to weaving the cloth. How else could I get just the right effect? Then, a fresh discovery . . . signs of wear on the favorite Levi shirt! The white weft threads were just showing through the faded blue surface warps—that nice denim depth of blue-on-white is achieved in just that way. Embroidering a fantasy flower on Roland's elbow was discovering a new dimension in an old favorite. Denim holds a needle without fraying and pulling. It's easy to stitch without a

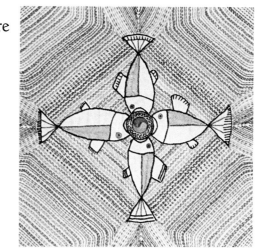

hoop because it holds its shape. The depth of the color and weave add something to the background while you enhance the foreground. Soon the frayed collar and cuff were turned to use as a stitch sampler. We were off! (Of course Roland was still reticent about flash and the first patterns were fairly circumspect.)

It wasn't long before the first psychedelic phase gave way to a certain mellowness and we settled into a Subud way of life as a spiritual path and means of identification. Lucas was born. Names changed, in Subud fashion. Leif became Hobart. Ben became Roland and Rain (a second-generation counter-culturist) became Alexandra.

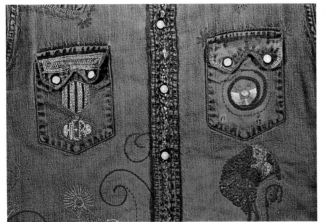

One day, I felt such a rush of love and warmth for the old man that I had to pull out the shirt and write him a message—a purely decorative one—with no hole to cover, no mend to make. In pink and gold on his front pocket I stitched a badge of office, a permanent memento of my esteem, a medal saying "HERO." I held my breath in fear that it would be too personal or too flashy for him to feel comfortable when wearing it to work but I'd made the HERO slightly difficult to read, slightly funky, and it passed inspection. I guess he got the message.

The Subuders went on a Moslem craze. I stitched a mosque-like building with gold and purple onion minarets, which Roland named "Café EAT," so I promptly stitched the name in too. It was a perfect (though a little obscure) statement of our position and style.

Roland's flash capacity grew with the shirt. Pieces of our lives became stitched into it. He'd

come a long way, baby, by the time I had to line the inside of the shirt with old sheets and quilt it down with all-over patterns. When I put in the front panel of Christ walking on the waters, he didn't even blink at seeing the old boy emerge. By now, Roland was, so to speak, wearing his heart on his sleeve. His private life was public—any bolo could stop him on the street and say, "Somebody must love you a lot to have done all of that for you."

At the radio station where Roland talks in the wee hours of the morning, one fellow got angry, in a sort of rueful satirical way, every time he saw Roland in The Shirt, or even in one of his other items of clothing which were getting old and familiar enough to warrant personal embellishment. Our friend had just separated from his wife. She had never "cared enough" to sew on even a button. (Sure, the man needed liberating, but that's another book.) After several such reports, I began to feel compassion for the poor soul since he obviously needed a talisman of power. Having

gained some feeling for his state, I thought I might do something simple and light on one of his old shirts, something that would cheer him up a little. I asked Roland to get some bit of clothing for me to work on. No soap. He turned us down. It was just too personal, the fellow said —too intimate.

Another time, our foster son Jeff was interested in guitar lessons and met a nice, gentle guy who said he'd help him out. It wasn't a situation where cash payment was expected. Ah, I thought, this looks like a job for embroidery. Bring me your old shirt. "No, no," he said, "a

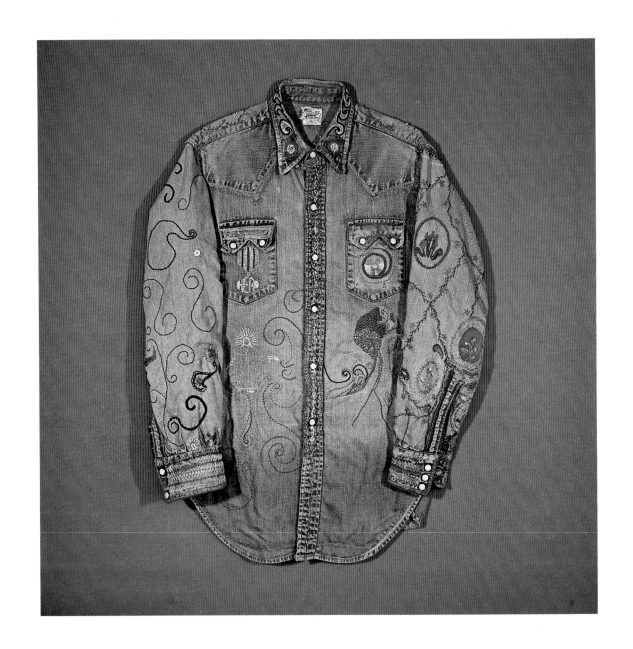

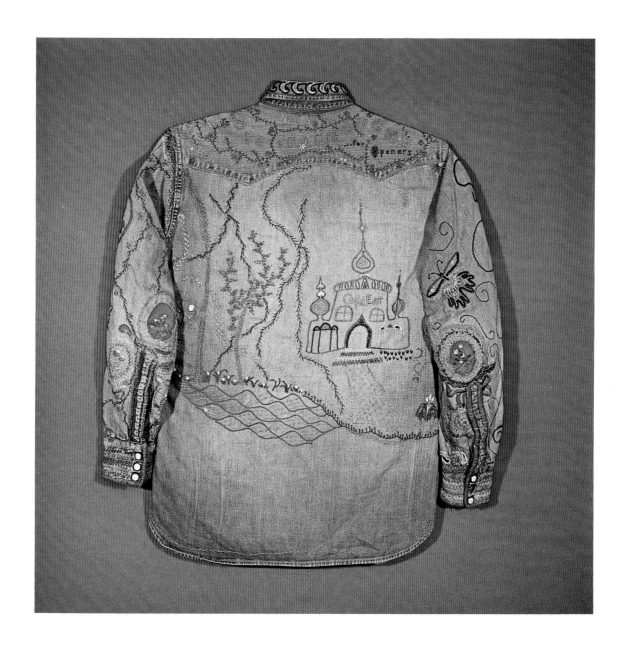

thing like that must be done of love." No connotation of sexual attraction here; just an opening of self to a stranger is enough to be scary sometimes.

But that opening of self is what this folk art is all about. It's the story of this opening: in individuals, watch each subsequent work they do; in the culture, watch more complex messages and sensitive treatments appear as the artists become more proficient, as the medium continues to loosen up. These artists are trying to show us something of their inner selves. (I once tried to get an apprentice to stitch her inner demons onto her pants. I still wonder if she ever got them out.) We want to externalize these states so that they may be read by others able to understand the language, attracting companions of the brotherhood.

The smiling-face craze was an attempt to mass-produce and distribute an individual self-pronouncement and a power talisman. And when you mass-produce, you divide the power of your statement into as many pieces as the items you manufacture. They all too often end up saying "$" instead of "!" or whatever was once intended. That smiling face was the most successful commercial symbol of its sort (with the peace symbol a close second), and just feel how watered-down it is. Even "Keep on Truckin' "—another widely-traveled symbol—carries only as much more power than old smiling-face as there are fewer pieces in existence. (There's a diminishing point to this analogy, but it works just the same.) So keep smiling. And keep on truckin'.

There aren't any patterns in this book because the patterns are all within, languishing and longing, like dreams, for expression. Don't be daunted by lack of skill or technique; there are scores of books and several friends who can teach you French knots or chain stitch and, God knows, we've lost a lot of other skills since Grandma's day. Many of the needlework pieces here are amateurish by her standards, but do heed the message from within, and try to break out through the channel of these visual images.

Roland's number-one shirt is now so thin that it has been retired from regular use, to be saved for special events and ceremonial occasions. He says that power-objects and power-costumes are useful for more than the celebration of rites or demonstrations of joy. He wears them in tight situations, like confrontation with management types, where intimidation must be resisted. "This shirt," he says, "carries power because power has been invested in it—a circular flow of energy. It can be astonishing to watch a heavy ego-player or profiteer-type have to face that shirt and begin to sort of curl at the edges."

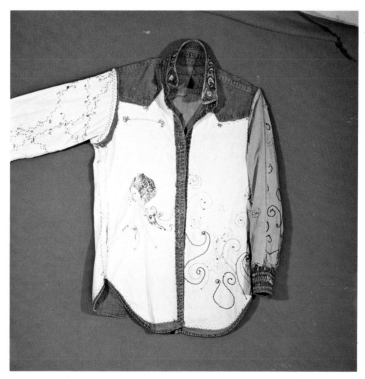

As I work on the shirt and Roland wears it, he feels the power I invest in the making and he invests further power in the recognition, which further inspires me. An upward spiral. The evolution of the shirt continues. The empty oval frames on the sleeve are still favorite places of mine, to watch and wonder over—when will the time come to fill them? Meanwhile, the shirt needs servicing more often lately and spends more time in the shop. Some of the patches need patches. It's time to start over again.

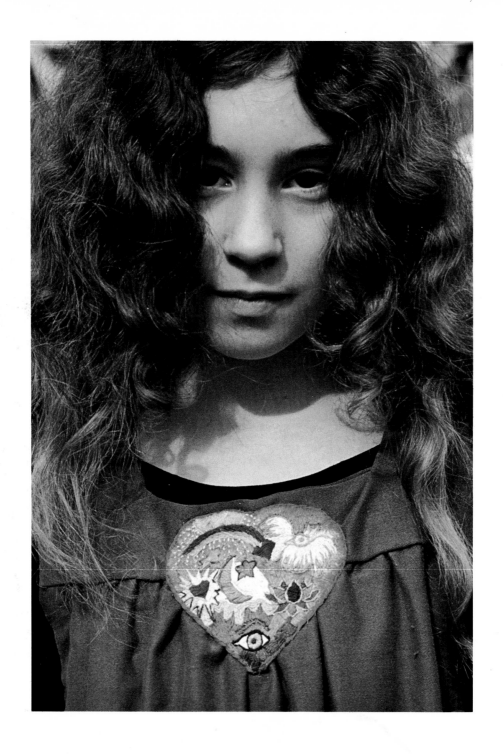

14

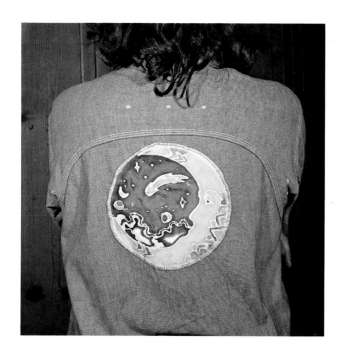

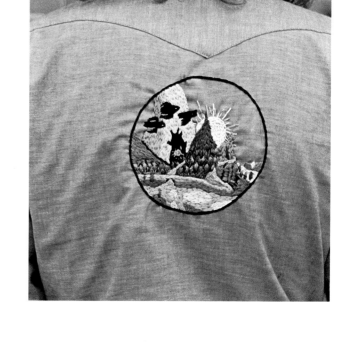

And here I sit with the experience of gathering together all these talismans of people's inner lives, filled with wonder at their willingness to share with us (and thus with everyone) these private messages from within.

Timothy Leary spoke of the revolution in consciousness. He took to ethnic clothing early—remember the smiling doctor in the Nehru shirt? All of those mandalas brought to us by Leary, Carl Jung, and Inner Space have served as fine channels to lead us back to ourselves. Now we make our own.

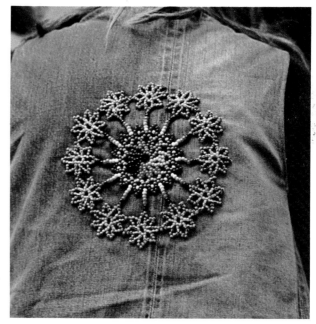

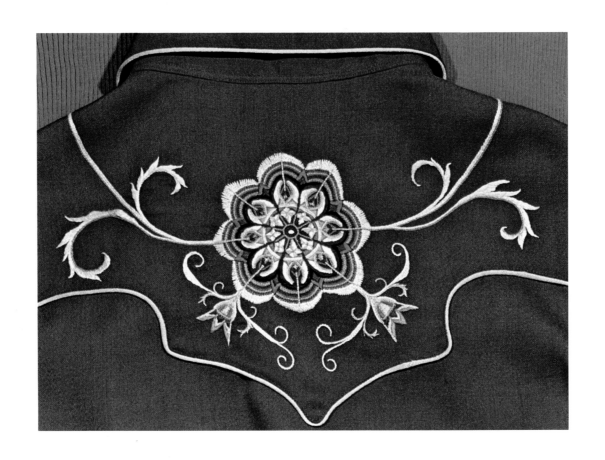

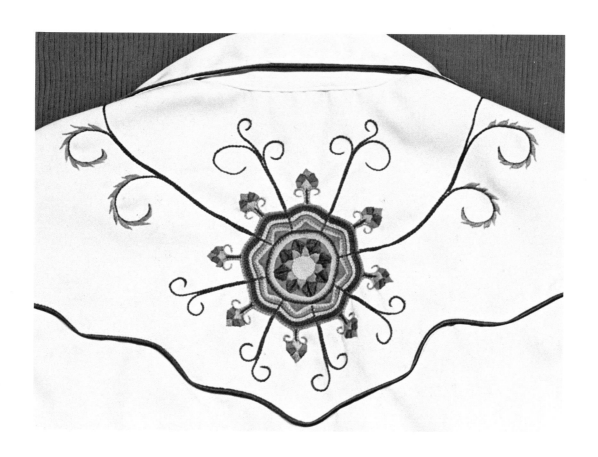

17

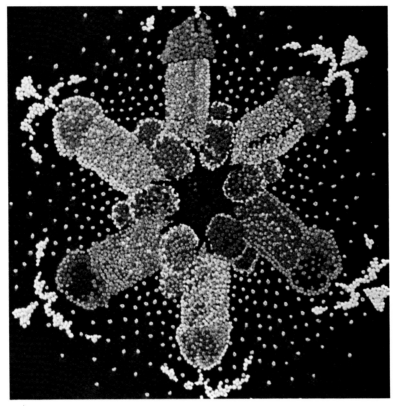

by S. Jackson, courtesy of Mrs. Linda and Dr. Paul Seward

The revolution is a cultural one, to my mind, and a very sweet and gentle one at that. One of the increased freedoms over the past few years has been the erotic—erotic themes, lovingly handled! A celebration of fertility and sexual joy, instead of throwing rice at the wedding of friends.

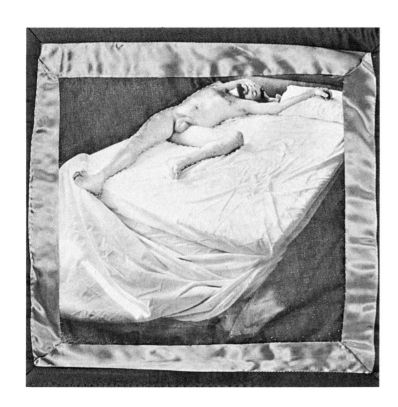

Above, an intimate picture of a husband, photographed and printed on fabric by Joanne Leonard and pieced at the weekend quilting bee that produced the four fanciful quilts mentioned on page 36.

The picture on the right came to me at orgasm and I was just able to make it to the pencil after the old man left for his insane night radio gig. I first sketched out the bare outlines, then took up a needle and thread to catch the spirit.

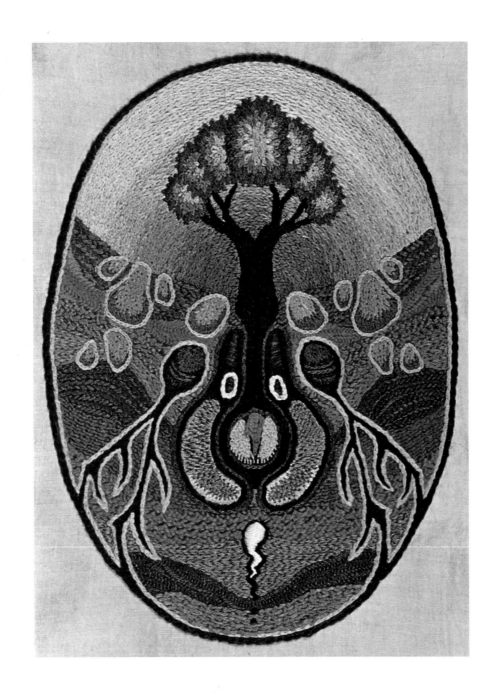

All those people who took acid in the sixties are ten years older now. I remember wondering what would happen when we got older and began to form our own culture, infiltrating the old one by ingenious drug-crazed peace-and-love tactics.

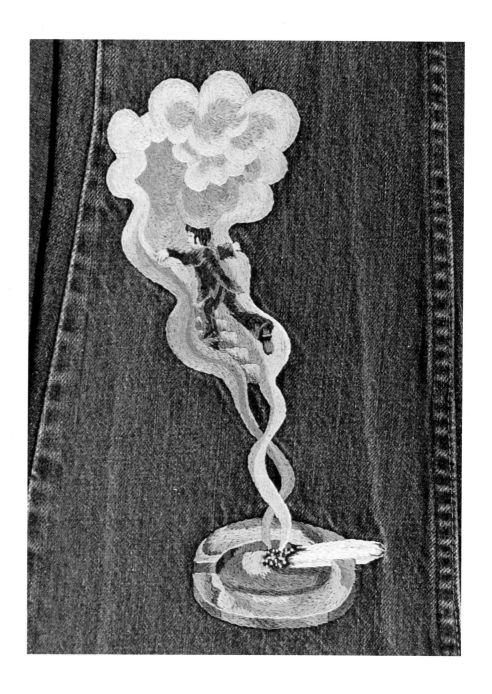

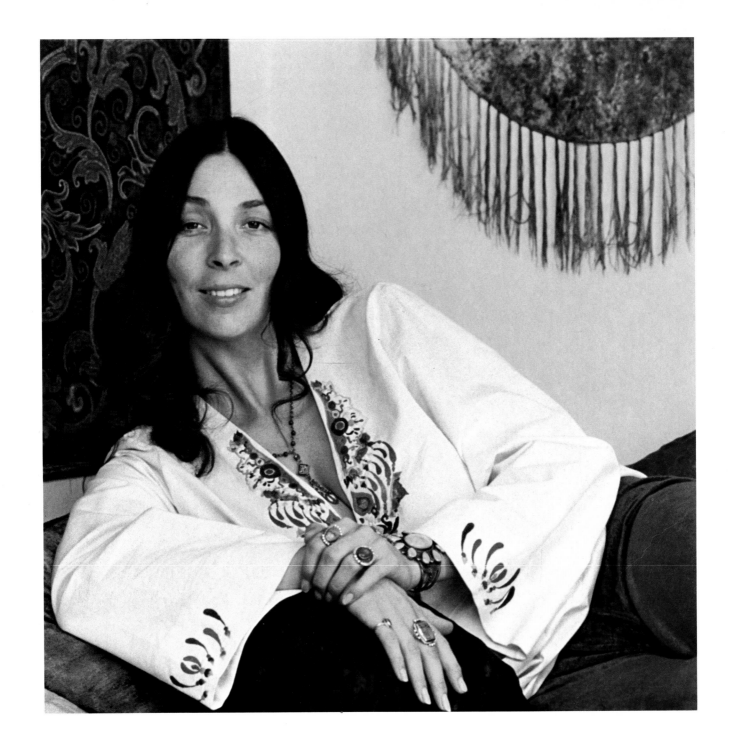

The United States continues to be the great melting pot. Now we're opening our arms to the spiritual teachings of the world. With the teachings come new images, and icons from Tibet and Nepal are transformed like this. My sixties mind was blown by all of the teachings made available. Secret doctrines from all cultures, now easily at hand—"Tibet's Great Yogi Milarepa," "The Book of the Hopi," "The Teachings of Don Juan," the "I Ching"—arcane secrets of Tantra, Yantra, Mantra, Mudra and Asana, at popular prices.

Sometimes it's not easy to understand the wisdom of the ancients, even in paperback. So we find it translated into popular art, with messages accessible to all, and symbols for the mysteries as well! Some inner experiences lead to Tibetan parallels; others strike out on their own, in cosmic outer-space visions of inner-space concepts.

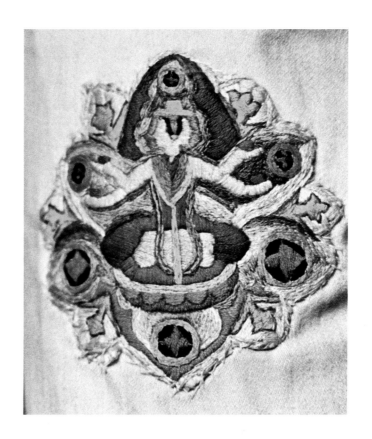

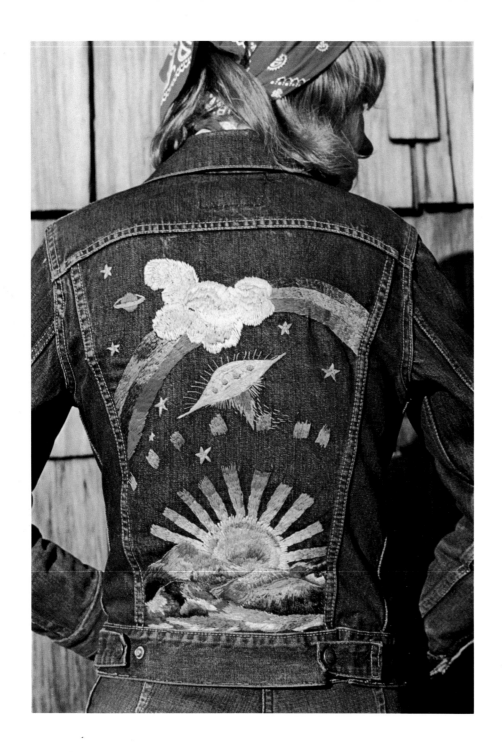

Pat Haines' Levi jacket, done in satin stitch with fine silk threads, came about when she found herself without paints and in need of expression.

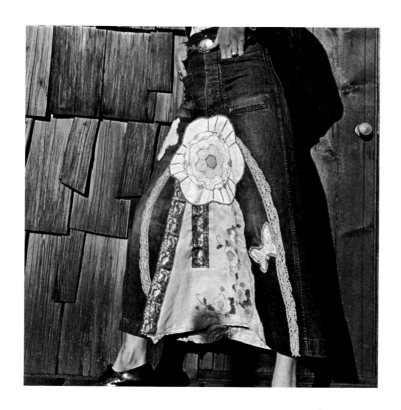

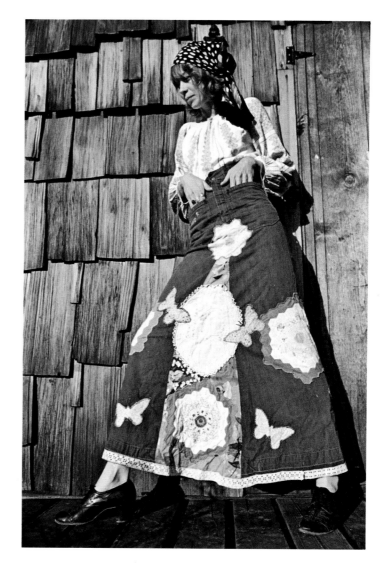

Pat was the first in my area with a jeans skirt but she claims to have found the idea in a British magazine of about 1969. My own investigations tell me that the jeans skirt was probably a matter of spontaneous generation, as colorful patching was, popping up in many places out of the ripeness of the times. New leisure time, brought by the welfare and food stamp economy and the general shortage of meaningful work were joined with new ingenuities and a desire to be out front outside as well as inside. This meant that new, but not too new, clothing was needed. They began to patch the old, preserving its comfort and familiarity, innovating from scraps.

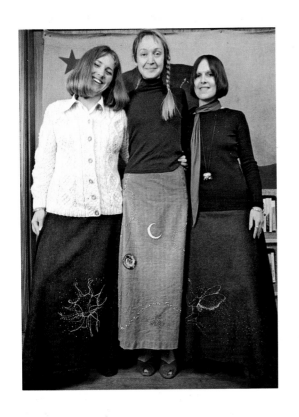

Many folks gained real inspiration from Pat. Some school children built and decorated their own art shop with her aid and direction and she meant a lot to S. Jackson, shown center with friend Ann Burlingame on the left in The Cosmic Ethereum Skirt and Gabrielle Henri, right, in Astral-Traveler-With-Stardust.

This detail shows S. Jackson's unusual and wonderful use of French knots, the only stitch she now uses, one that can drive embroiderers to tears.

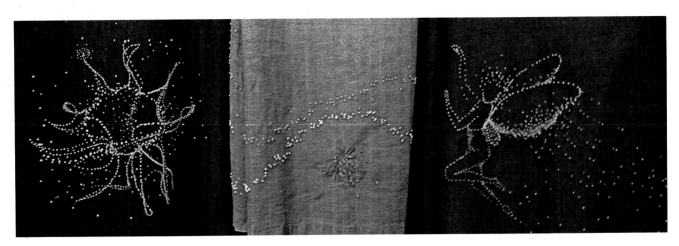

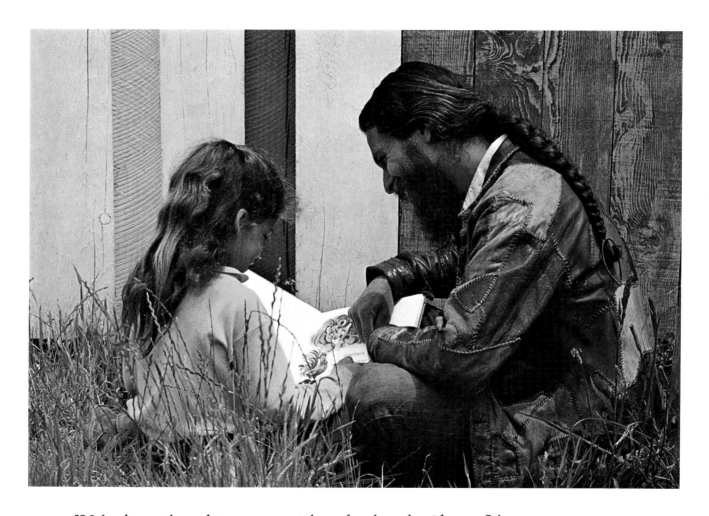

We've been pleased to meet a number of male embroiderers. It's the cheerful flip-side of women's liberation: people's liberation. This jacket was patched by Richie Quiñones until only one little blue bit is left to tell its origins.

Wilder Bentley's first time out resulted in this great Goodwill Harris Tweed with a serene oriental spray splashed across it. A consummate artist in many fields, he also made the jewelry he's wearing, utilizing simple, unmechanized craftsmanship—recycling ebony and ivory from old piano keys, carefully hand-sawing and hand-polishing elements on a brick sprinkled with abrasive powders—all without benefit of power tools.

I asked Wilder how he came to embroidery. "Well, I found myself trapped in a big city which, in its usual way, was enforcing its dictum, 'Thou shalt always be either earning or spending.' My artistic work was sliding to a halt. Suddenly it occurred to me that there was an area where I could re-route myself into productive work. That was to use the time I was spending in coffee houses trying to get my head together after some ordeal—or awaiting the hour for some ordeal to be enacted. So I quickly got together a kit from Kress's embroidery counter and enjoyed many an hour in the front seat of my 1950 two-door Plymouth fastback license BRS 891, during which I was able both to augment the value of my wardrobe and provide an Effective Disguise for passing unnoticed through the bands of roving tourists and idle citizens which today clog our sidewalks."

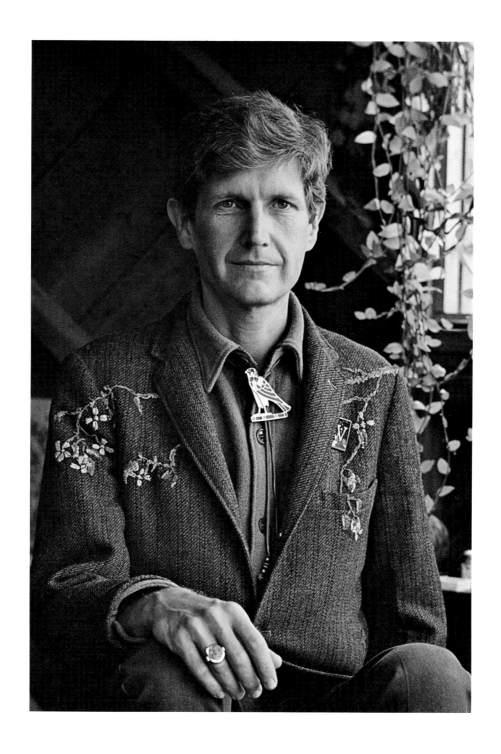

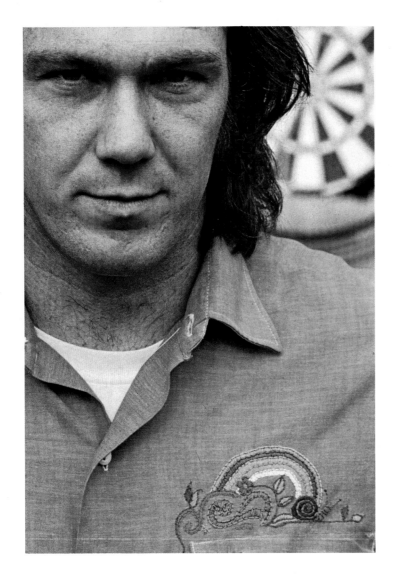

George Bailey, teacher, worked his own snail-at-the-end-of-the-rainbow.

"Enlightenment Doesn't Care How You Get There" is one of the best bumper stickers I've seen. Although grass and acid played their part, they re not the only path to a gramophone playing musical colors. Jerry Lucey teaches such things as stitchery and Latin at an alternative high school near San Francisco.

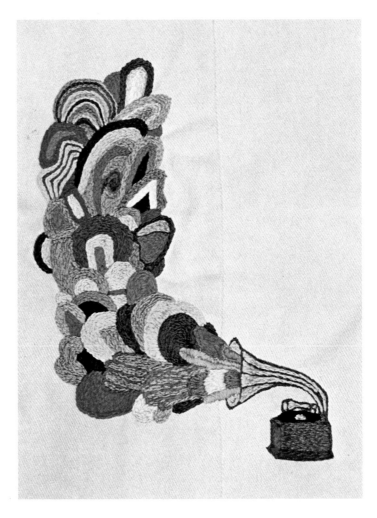

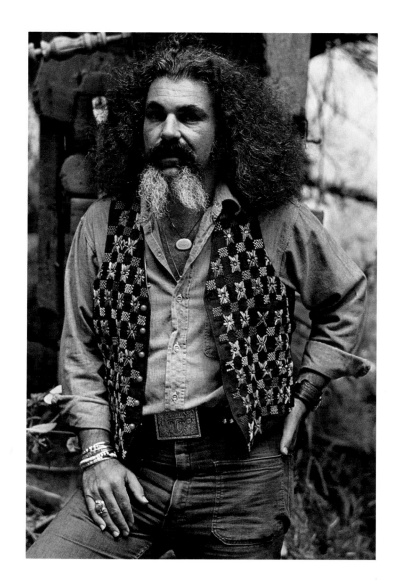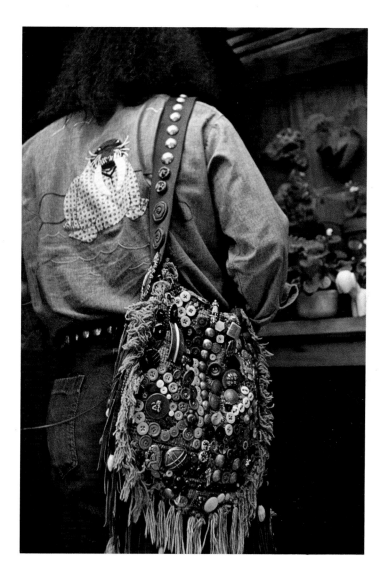

Bill Sapios is a leather craftsman, jeweler, and master of flash. His vest is a recycled piece with the rectangles of the original fabric used in a grid of Algerian eye-stitch with a sequin at the eye of each. His oriental carpetbag is decorated with patterns of pins, buttons and silver conchos, a nice step in the evolution of pinned-on badges.

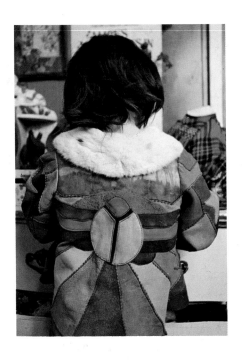 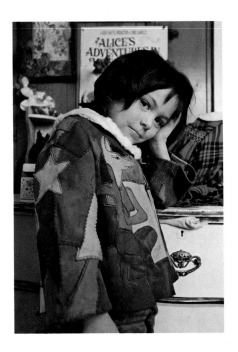

This patchworked leather jacket is a testimony to its own durability. Patti Towle made it for her daughter, who outgrew it and passed it on to Judith.

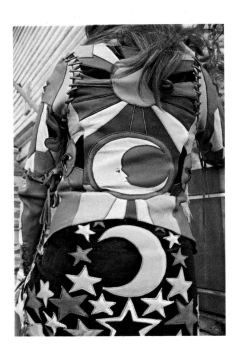 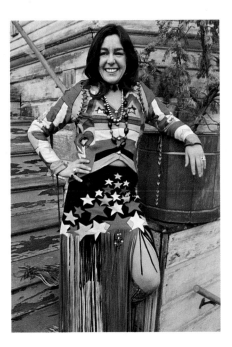

Patti's work in another vein—a performance dress for singer Lynn Hughes. Lynn patched one of the squares on the China Kelly quilt, page 37.

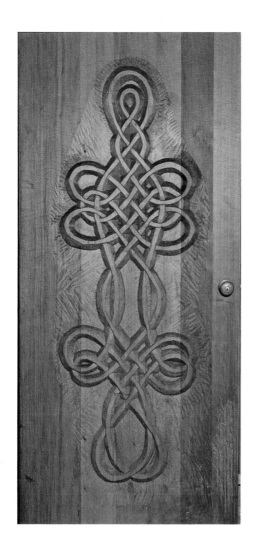
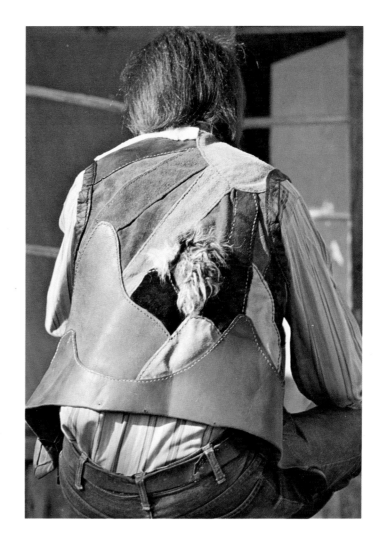

Woodworker John Barrow in a leather vest patched with everything from fur to latigo, stitched by hand in punched stitching lines —Nancy Denmark's first work with leather. John's carved door has great appeal to textile enthusiasts. He is noncommittal about the design, saying that he meant nothing special by it, but it has been seen as a vertical version of the Tibetan Knot of Eternity, denoting the indestructible qualities of meditation in the Tibetan mysteries.

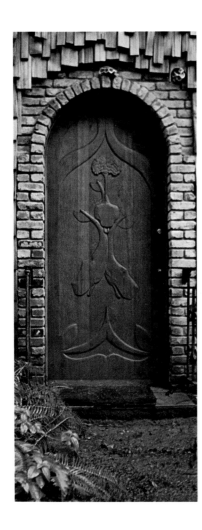 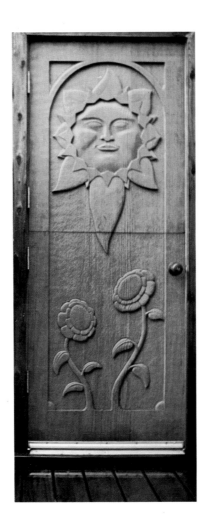 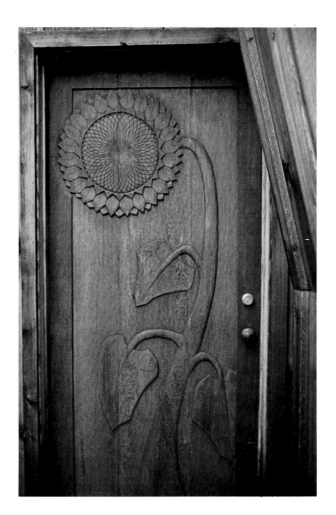

Kit Andrewson carves a variety of woods for doors like these, including the one with a yin/yang stained glass flower center in complementary colors. Kit's glass design was executed by Jeffrey Simon.

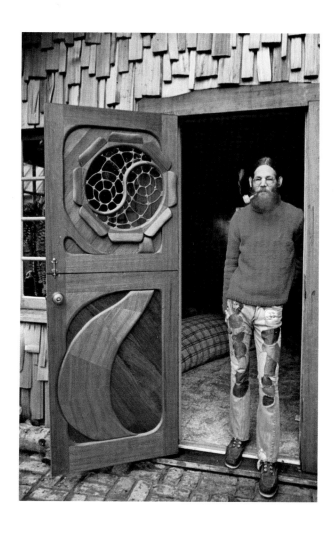

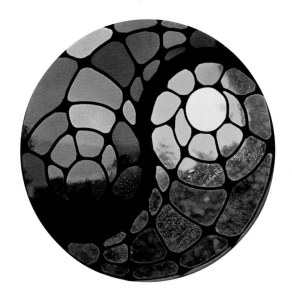

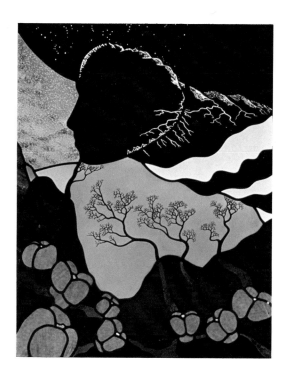

We find it hard to include stained glasswork as folk art but believe that Kathie Bunnell's qualifies by way of subject matter—peyote buttons working upward into nerve-ending root systems.

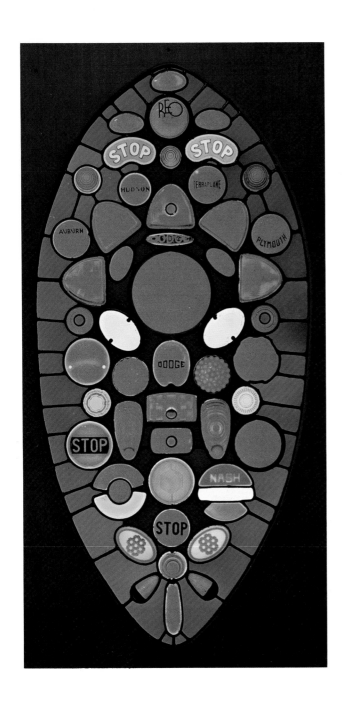

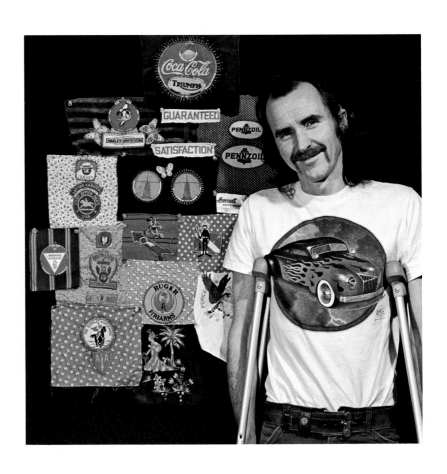

Patchworks and quilts are traditionally women's art. This one on the right, still in the making, is no exception, except for the square done by poster-artist A. Kelly for his daughter, China. Kathleen Rochester designed the quilt and friends of the family (a very heavy group of ladies!) joined her in the making.

(Incidentally, an old British tradition, just brought to my attention, is that of making crazy-patch quilts by veterans recuperating from injury. Kelly is furthering this venerable art by patching together the one on page 36 while recovering from a motorcycle accident. And that window on the far left was made from old auto taillights by the same fellow.)

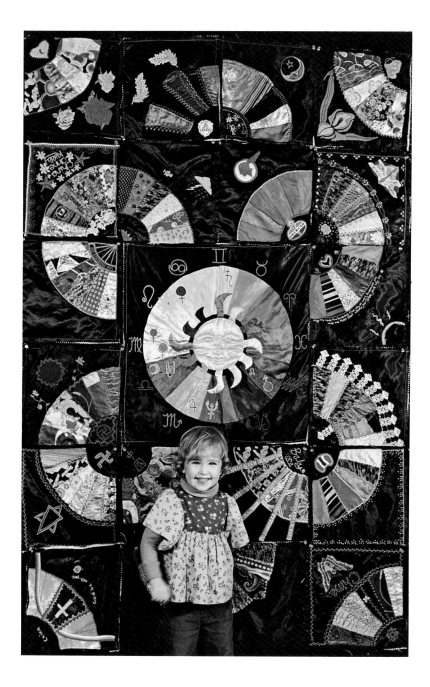

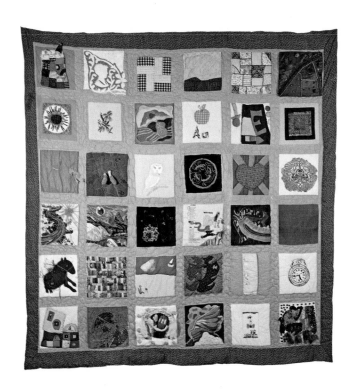

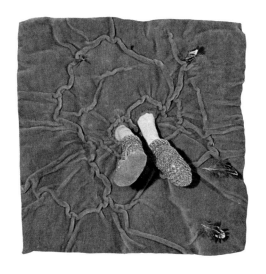

A series of four heirloom quilts was master-minded by Judy Raffael. Her usual medium is stained glass but she sent out letters to some seventy friends who came through with enough squares for four outrageous, if not wholly functional, quilts. One has an oilcloth pocket (to take lemon pie to bed with) and another has a little railroad scene, complete with three-dimensional fences and train, to play with when you can't sleep, I suppose. My favorite squares are those shown individually on the right: "Icarus Arriving" and the sun and river scene. You may have a chance to see a traveling show called "Four Quilts by Seventy Women" and choose your own favorite.

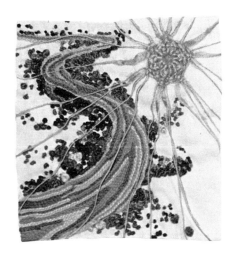

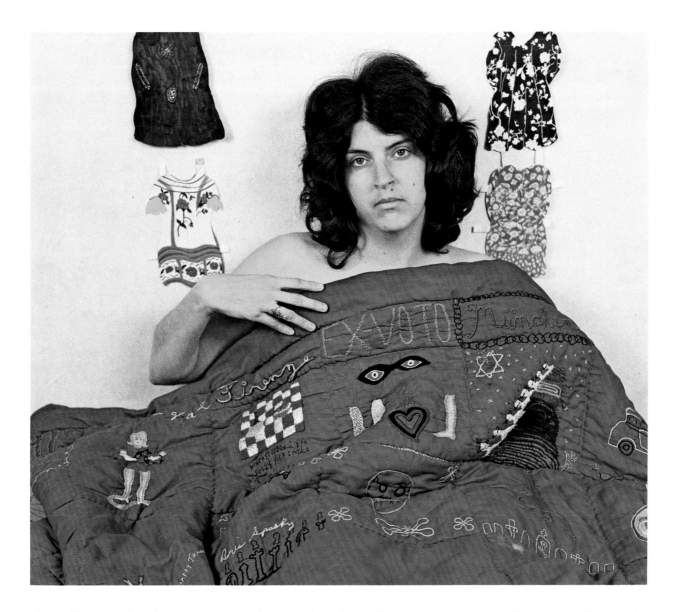

Ann Shapiro has her own special way of making fantasy into image. She normally works in watercolor, but as she accrued experiences on a recent European trip, she chose sleeping bag stitchery as the best way to record her impressions . . . a snake-charming lady in Portugal, a Boris Spassky-Bobby Fischer chess game, some memorable meals and, inevitably, corpses in shrouds, a remembering of the Munich olympic games.

Apple Cobbler, Carnation and Rat Soup share studio space as well as a love of bringing together myriad small elements and details into complete pieces. It can be interesting to see how they affect each other and yet how each retains his own individuality.

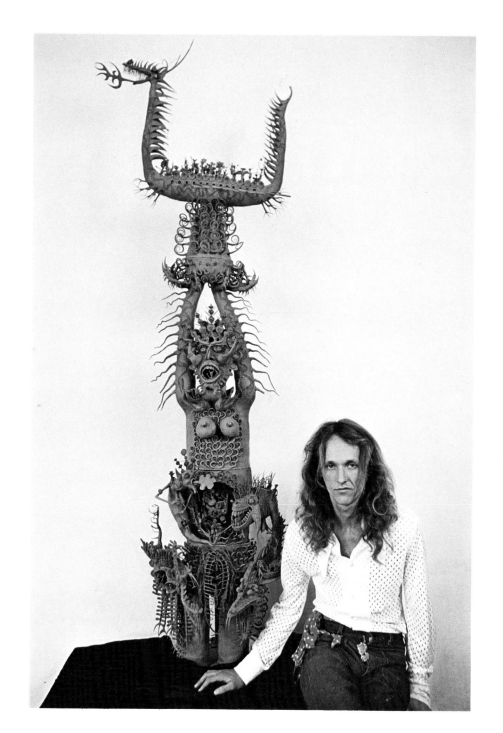

Rat Soup usually works in lost-wax bronze casting, but this ceramic piece called "Woman 1" shows all of his attention to detail. It gets right to my own feelings about the Wrathful Deities.

There's about a four-month wait to have a pair of these nifty shoes or boots made up. Apple Cobbler—also known as Mickey—talks easily in a stream of consciousness style about his foam-and-fabric shoes: "I don't want to make them when I'm not into it because then it won't transfer into them—the magic, you know? I like to work for people who feel that way about them—'It will make me sing better tonight'—and it seems that it does if you have a performance."

Carnation, sewing on a beadwork hat on the next page, is wearing a pair of Apple Cobbler shoes.

43

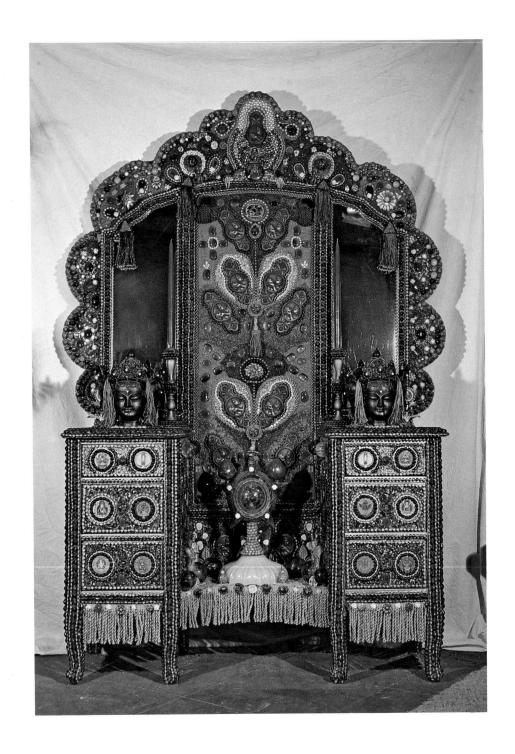

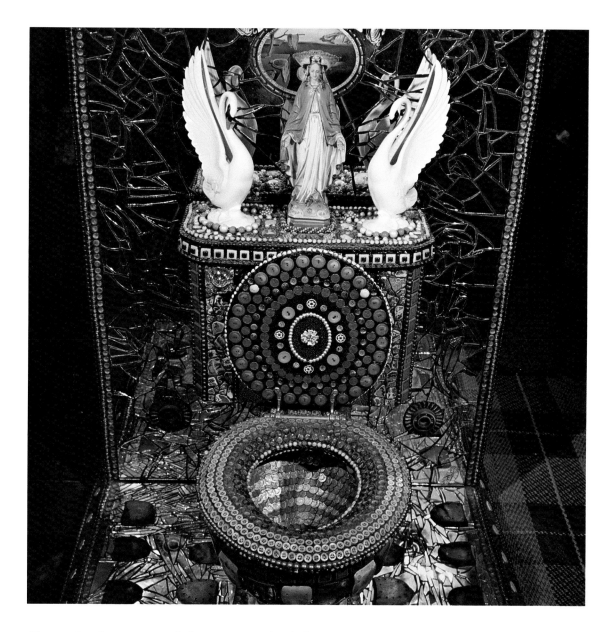

Carnation's encrusted dresser, on the left, is a piece from a work in progress—an entire bedroom environment. Epoxy stickum is the binder. The toilet above was made by Larry Fuente. As Carnation says, making these totems is like having a fantasy come true.

Then there are the Glitter Boys, popping up in the sixties and coming into their own in the seventies. What with the Cockettes and all, tne "movement" has undergone considerable fragmentation. Like cinema buffs discussing Hollywood of the thirties, Scrumbley and I followed the development of the Cockettes through the influence of Hibiscus and the Floating Lotus Opera Company to the first and legendary Halloween Party at San Francisco's Palace Theater, then into two and a half years as a performing group. They even had an engagement in New York. New York wasn't ready.

So here's the art of costuming, not crattsmanship, and the use of common elements like patchwork pieces and old doilies. It's all joined with a fantastic ability to achieve an effect, rivalling the scary old shamans of past times for sheer outrageous impact.

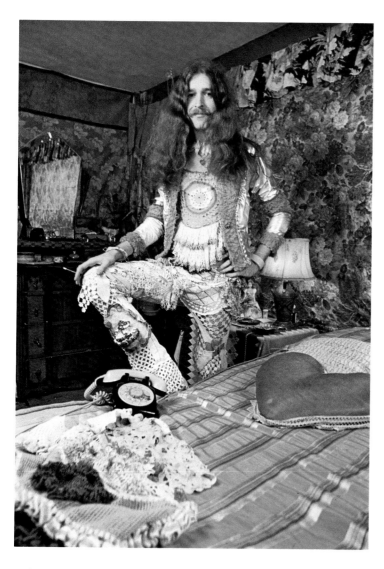

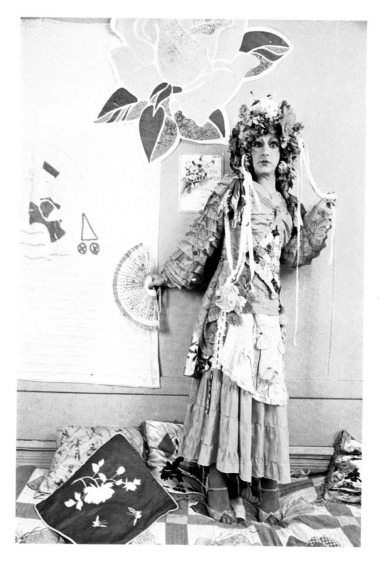

This is Scrumbley's performance suit, worn in a starring appearance with Pristine Condition. Scrumbley was among the first to use grandma's doilies on clothing.

Here is Pristine Condition, known as Prissy to her friends—another star. He usually appears as a singer with Paula Pucker and the Pioneers. "I had to work my way up from the one street of Hereford, Texas, baby." And, as she hitched up his dress, s/he said, "I'm a firm believer in safety pins!"

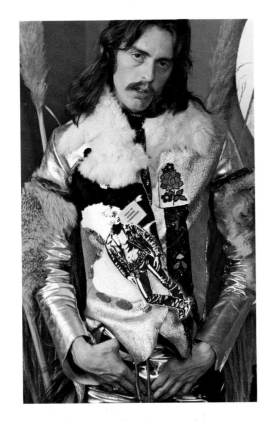

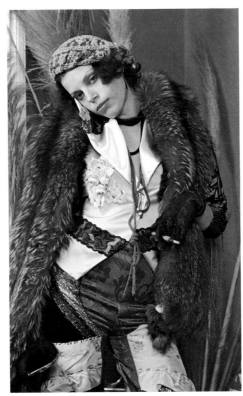

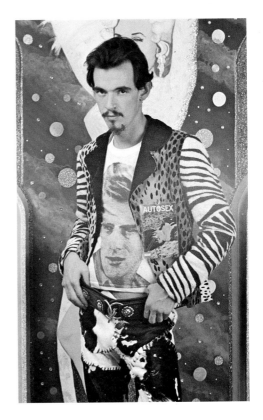

Billy Bowers in gold kid with monkey
and zebra fur. His creations
are real flash.

Lizzie . . .

Snappy . . .

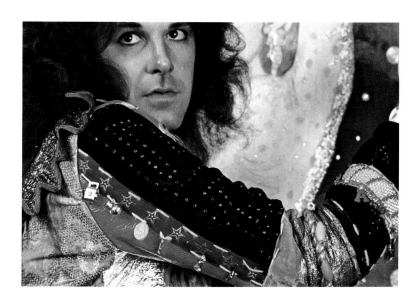

Babette . . . Lizzie again . . . all Billy's designs.

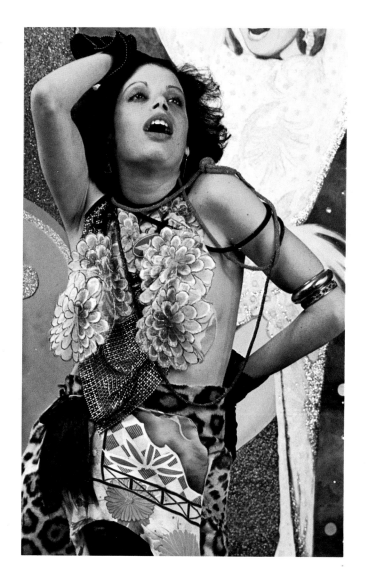

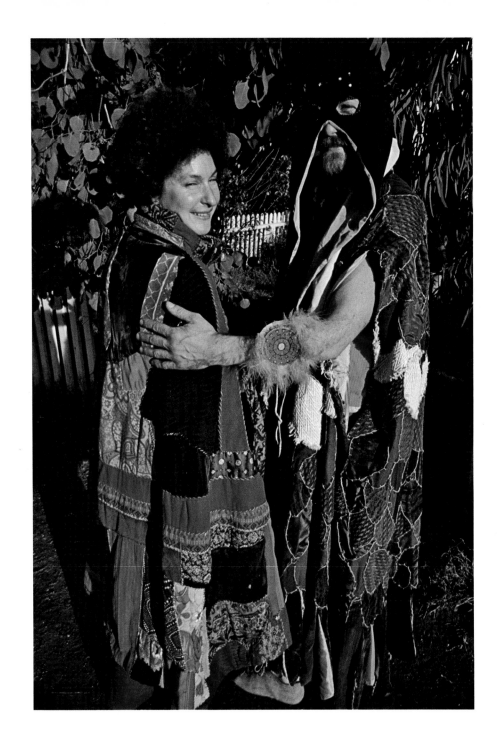

Another kind of shaman's outfit is worn by Gino Clays Sky, the Eagle Poet. Neshama Franklin, standing with Gino, made up this eagle cape for him to wear while he gives public readings of his eagle poetry. The beadwork is Idaho Shoshone. He has written several poems in which eagles figure and the magic of his cape makes it possible to conjure up the spirit.

Eagle
I am Wounded Knee
Spirit

My eagle flies
through the soul of Wounded Knee.
My eagle is the Phoenix
rising through the soul of Wounded Knee.
My eagle is the Thunderbird hunting
for this Earth's Spirit through the soul of Wounded Knee.
My body is the eagle killing
for food over the plains of Wounded Knee.

My Soul is Wounded Knee.

Inside the layers that are spirit
where the winds blow Winters hard across
the earth
the dancing continues the Prayer
Earth Drum
Sky drum boom
Winter sun drum
beat
boom the voices sing
the new Spring Phoenix chant beat
spirit soul boom buffalo run
eagle scream
the doe hides under the juniper
warm from the snow that muffles the tanks
moving into circle.

The dance circles tight around the fire
the tanks circle cold steel death
the eagle circles
above the inner fire chant of prayer
traitors cross the fire
souls shivering in unblessed goose down.

The drum steady
through the night calling
the new land free of enemy faces the animal
spirit Godman eagle moon
snow prayer.

I am the Eagle free sky
dance
God Spirit Man
eating the tanks
enemy circle of death
God Spirit Man
The fire melts the death steel
the tanks change into buffalo
the circle changes into one God Spirit Animal
Man
the singing consumes the enemy
the Power eats the devil
dance
Animal God Spirit Man

My eagle flies
through the soul of Wounded Knee.
My eagle is the Phoenix
rising through the soul of Wounded Knee.
My eagle is the Thunderbird hunting
for this Earth's Spirit through the soul of Wounded Knee.
My body is the eagle killing
for food over the plains of Wounded Knee.

My Soul is Wounded Knee

Dance
Animal God Spirit Man
Eagle
I am Wounded Knee.

—Gino Clays Sky

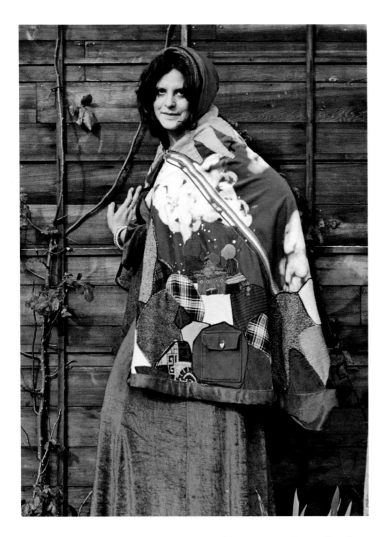

Neshama's cousin Vickisa makes a very foxy little
Red Riding Hood in another approach to the warm-
and-lumpy cape. This should give heart to begin-
ners, for she claims that she cannot stitch a bit.

Starting with an old Moroccan cape, she added
clouds by chlorine-bleaching blue material and
patched bits of this and that to the bottom. A simple
and fetching appliqué-and-embroidery bird flies
past the rainbow and into the sun. A grounding in
technical skills is nice but not necessary.

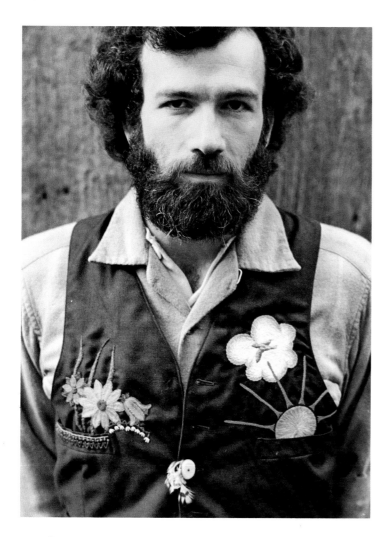

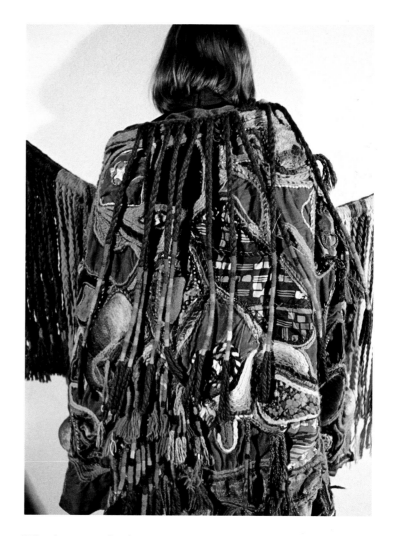

Joe Gaspers is another member of the Vickisa and
Neshama clan. His vest, above left, was embroi-
dered by Sue Van Brunt, who was also responsible
for the two wonderful patches on pages 20 and 21.

The lumpy cloak comes into its own in this age of
stitched, sewn and stuffed works. Dorothy Flash
used crewel wools and multi-colored fabric scraps to
make up a very heavy ritual garment. Her experi-
ence resembles that of many of the folk artists
we've talked to: the spiritual nature and pleasure of
the work—the process of the work—is the best
reason for doing it.

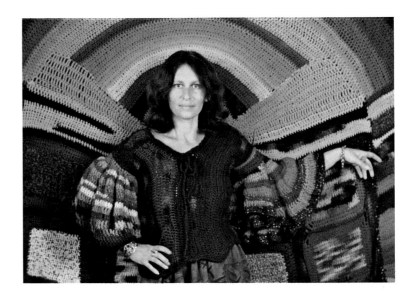

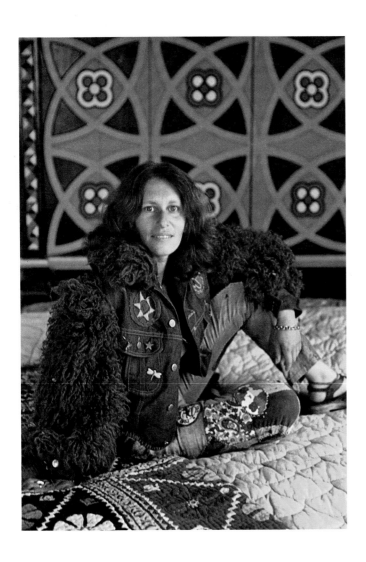

Fashion, Fad, Folk Art—how will the things in this collection or the numbers which you are creating survive the forces of popularity and mass production? Will popular fashion just chew them up and spit them back, as has happened with Native American jewelry, and then pick them up again on some future spiralling round? I'll guess that good conceptions, like Judith's crocheted work, will survive; the rest will transform and be absorbed. Some of it, like Judith's fuzzy-armed jacket, happens within a fashion or fad. There is indeed a place for the ephemeral.

Judith Weston's crocheted cape, "Homage to Tomales Bay." "I never was the sort of person to want to be rubber-stamped. I want to stand out."

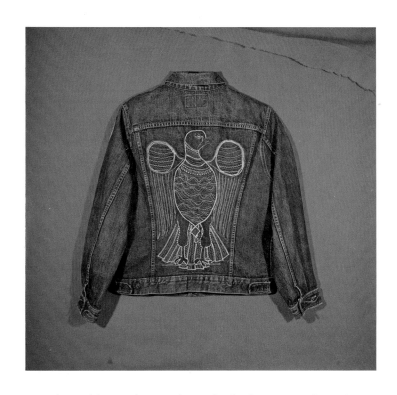

Eagles are a traditional symbol of power. A sewing machine with a good selection of stitches can provide a quick means of decoration in imaginative hands.

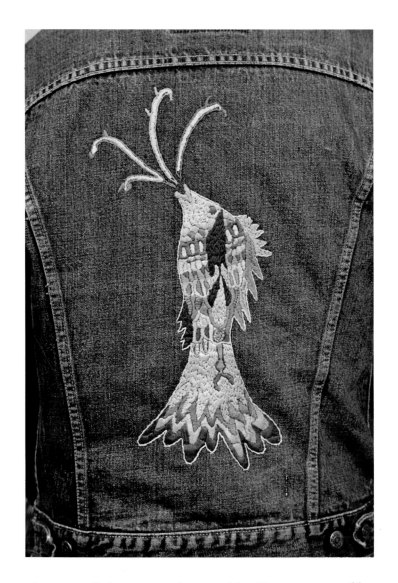

A nice collaboration, designed by Ree, executed by Kathy Howe.

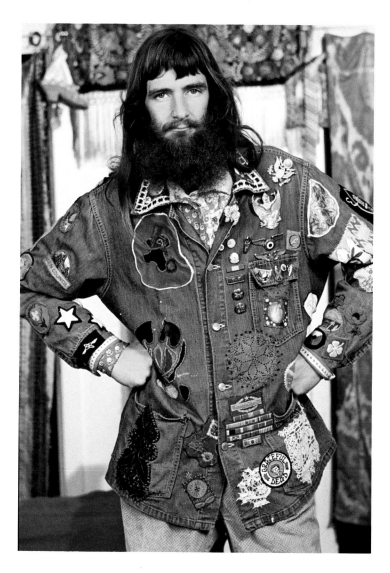

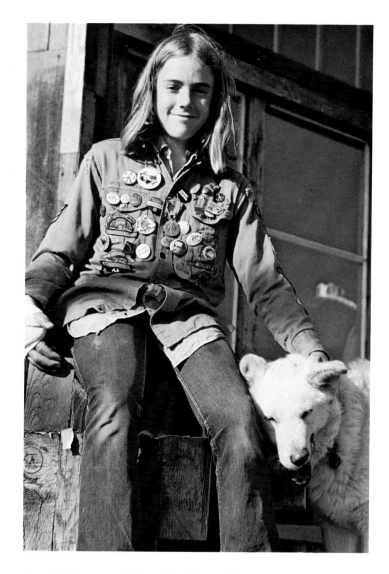

Charlie Stewart's wife, Jeannie, started this jacket years ago, with the appliqué in the middle of Charlie's right side. Daughter Sylvia at a tender age contributed parts of the embroidery as birthday presents to Daddy.

Son Hobart and faithful dog Chang. Hobart's thrift-shop Boy Scout shirt is festooned with badges, patches, medals and buttons, collected and pinned down back before embroidered jeans and shirts were common. The mood continues into the present.

57

The next group of artists bids fair to make it in the high-fashion world. Alex and Lee and Kaisik Wong have sold in such places as Saks and I. Magnin and have made the pages of "Harper's Bazaar." After we photographed them individually, we discovered Obiko, a San Francisco shop which shows fine examples of their work as well as Karen Warford's and the Miyamoto sisters'.

From Alex and Lee: "Within the meditation of Love and Peace lies our inspiration for creation. We view ourselves as instruments through which a psychic language of affirmation materializes. We seek reflections which carry one to visions where contrast is har-mony. We view our jewelry as devotional talismans to adorn the temple of the body. The moment of all possibilities is the time-space of our perspective. Our process of collaboration leads us to the mystical reunion of at-one-ment."

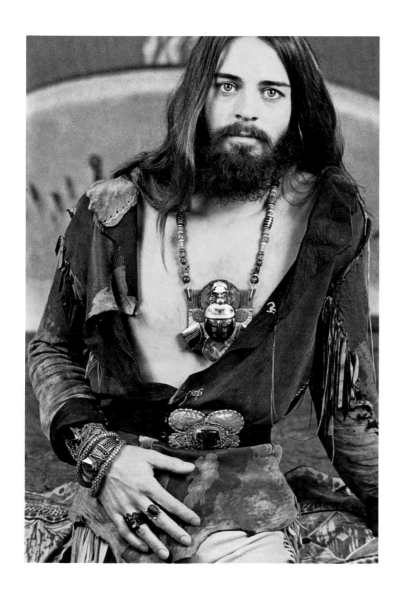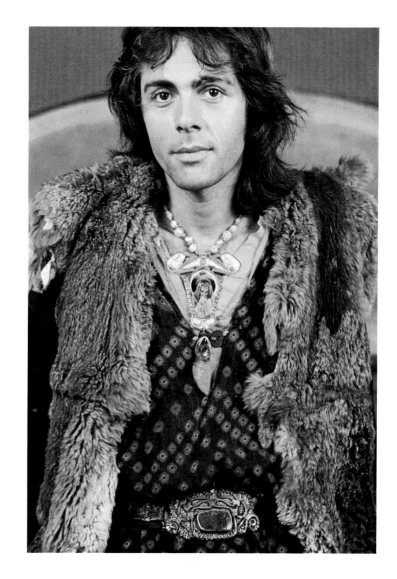

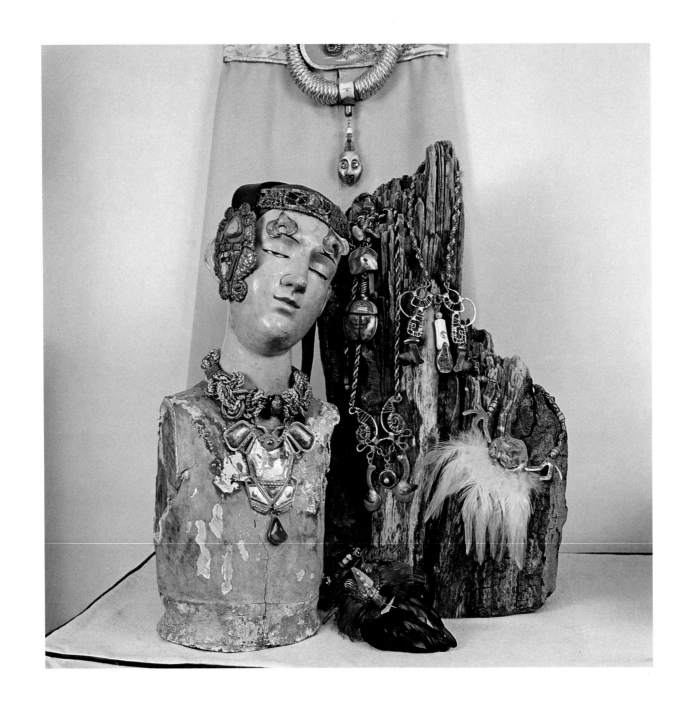

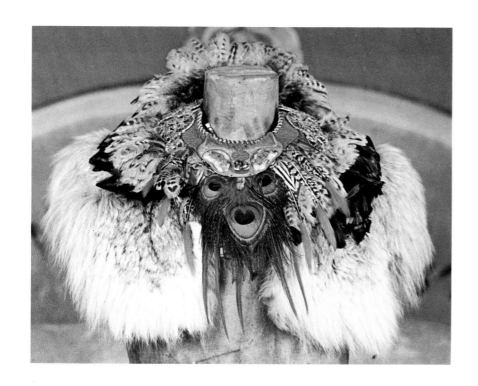

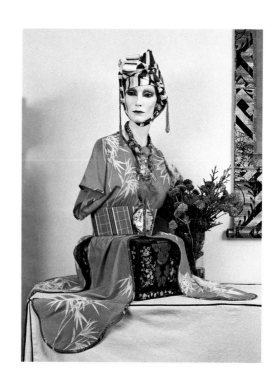

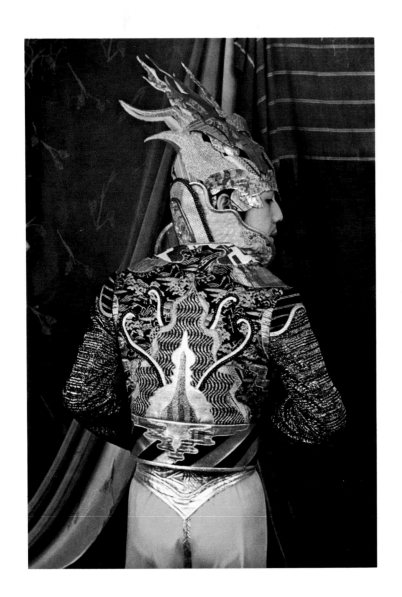

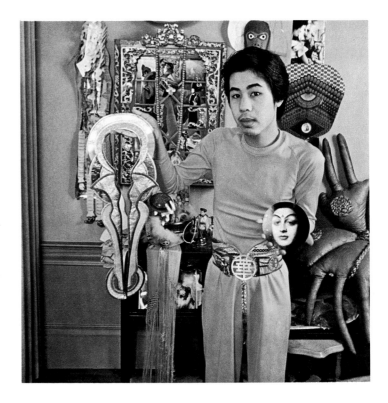

Kaisik Wong: "I like to view the Egyptian-Coptic area of design from a more accessible point of view." He is holding a picture of his partner, Jesus Santiago, who designs with him.

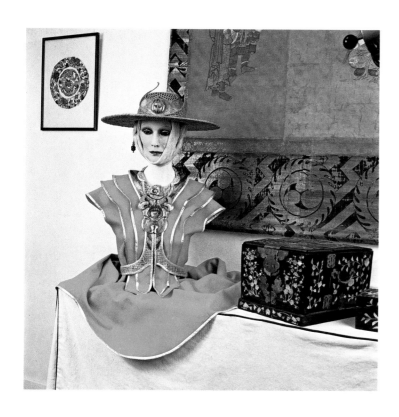

"People are opening up more and finding more reasons to dress in ways that show their emotions."

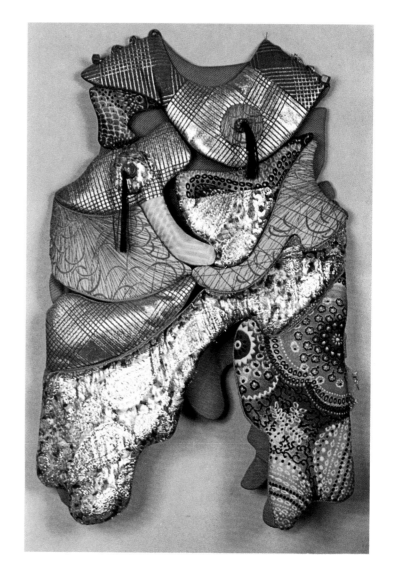

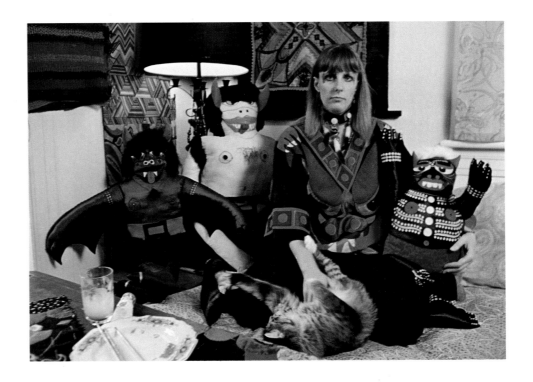

Karen Warford's devil dolls sometimes get folks edgy.
They remind me, again, of the Wrathful Deities . . . if
you can't keep to the pure light, they'll try to scare you
back. She made the little black horse, she says, at the age
of four! And here's another, up on the left, made in her
early twenties.

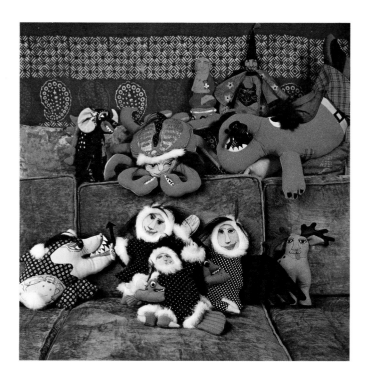

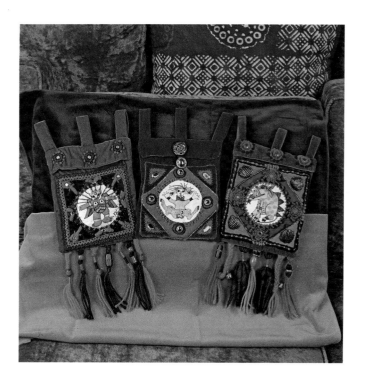

Karen's current Eskimo dolls make one look
forward eagerly to her next decade.

The appliquéd shirt on the next pages conjures up Pacific North-
west Indians for me. Karen says, "Well, I had been turned on by a
museum totem pole not long before, but the face is just like my
ex-old man's, and he's half-Chinese and half-Italian."

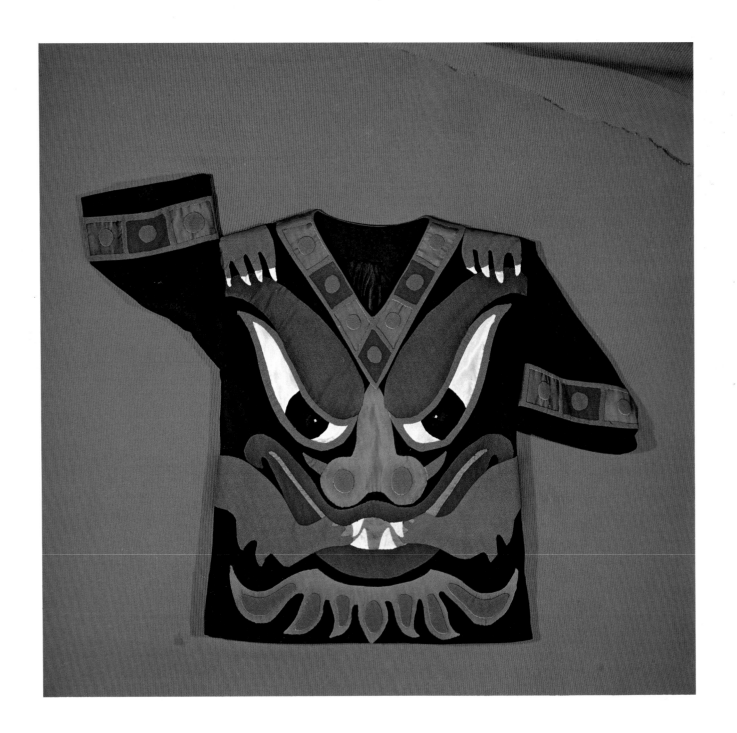

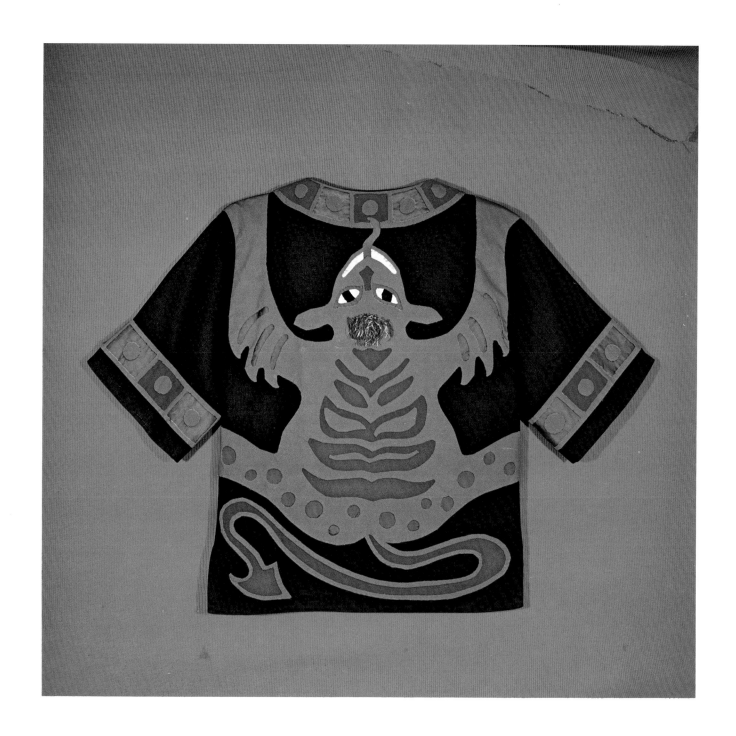

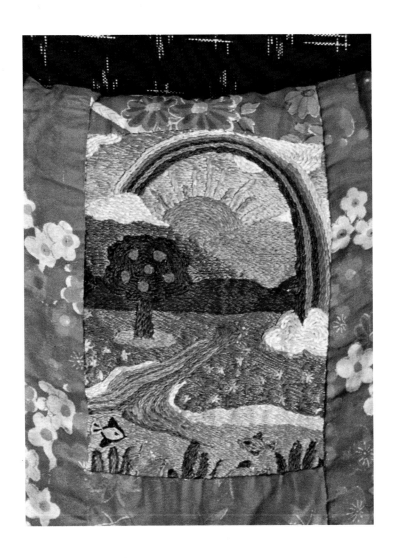

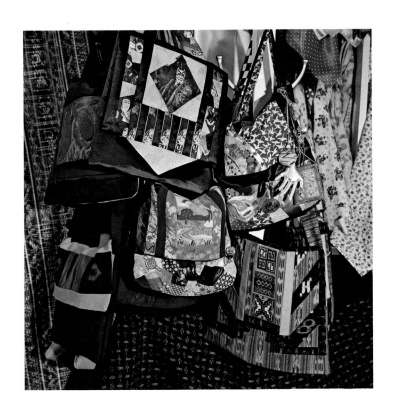

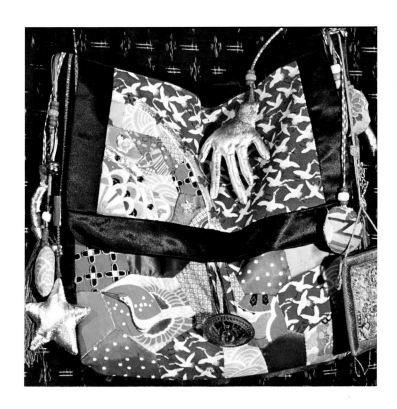

Alice and Susan Miyamoto are sisters who run a
San Francisco fabric shop. This jumble of lovely
Satin Moon Bags, embroidered and patched
elegantly with old and new Japanese silks and hand-
woven cottons, demonstrates Alice's and Susan's
expertise.

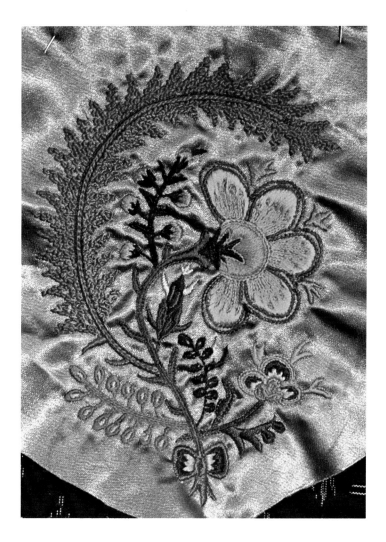

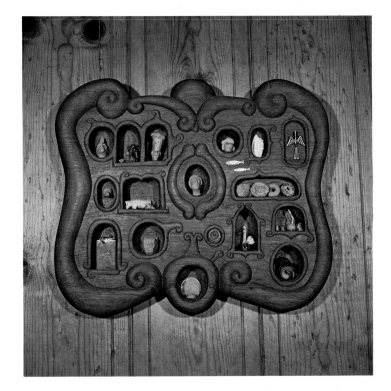

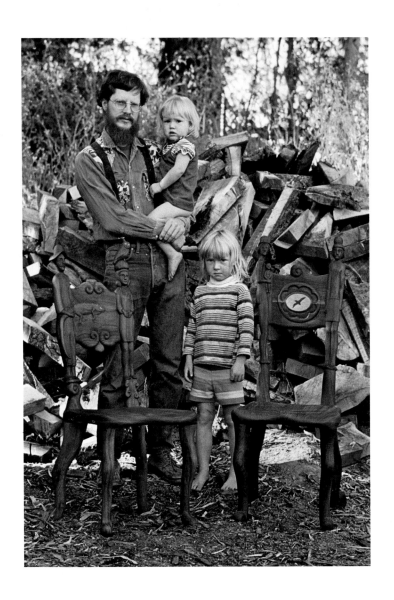

Hannah Bauer's patchworks and puzzles are sheer delight. Imagine the quality of lives surrounded by these and John's wonderful wood carvings (here and on page 72), blended with Maya Moon and Naomi Sun and a whole bunch of chickens. (By the way, folks, chickens are the folk culture's latest, hottest symbol.)

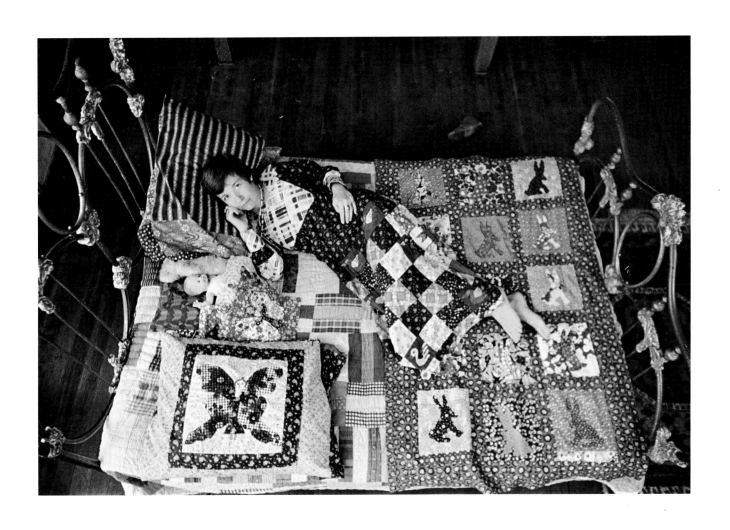

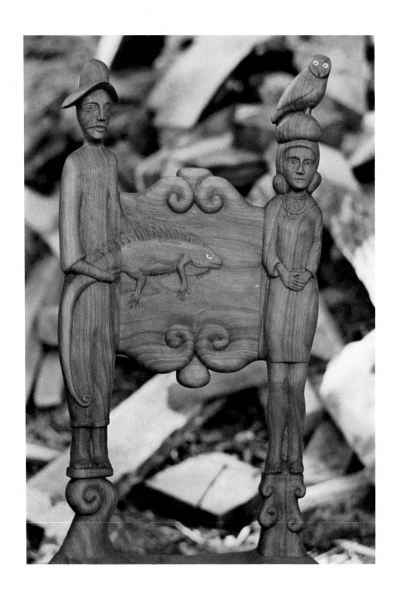 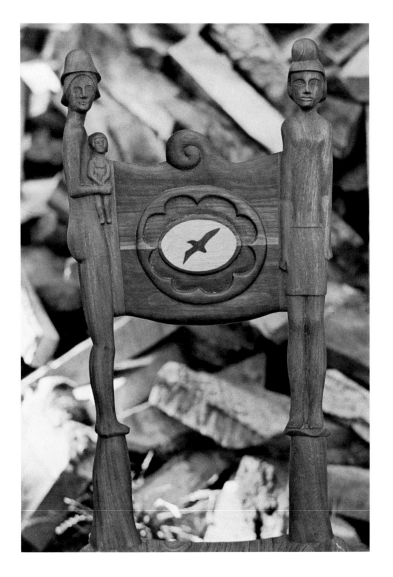

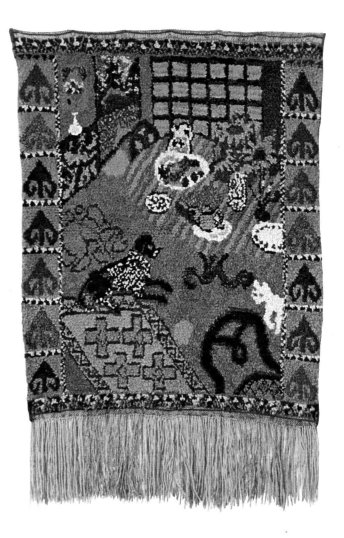

Hannah and John also live with this rya rug on the right, hand-knotted on a woven back by Suzanne Taylor, who lives with one of Hannah's puzzles. (Swaps are more common than sales among a large number of folk artists.)

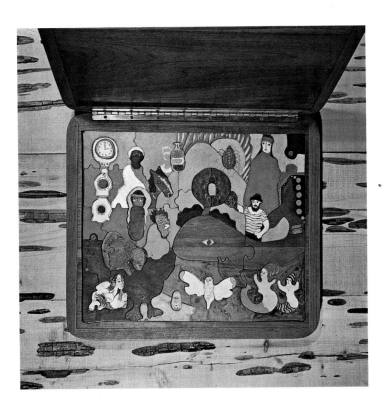 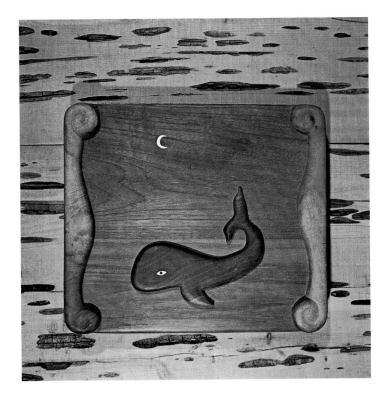

John did the enclosing box, Hannah the puzzle.

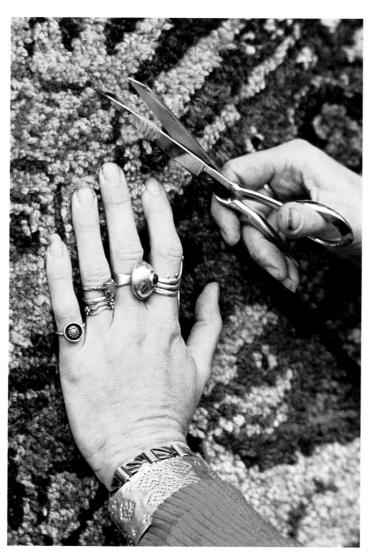

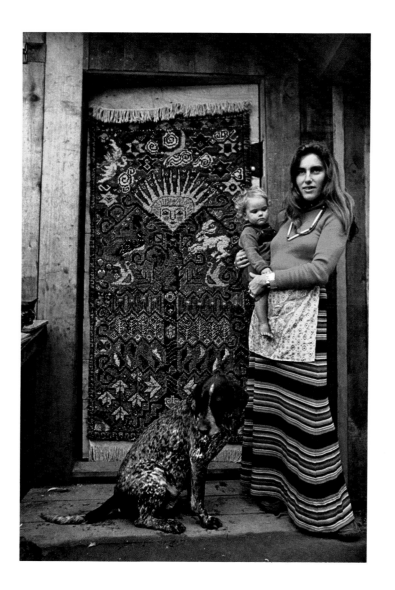

Suzanne, clipping and finishing a rya rug.

There are dresses I like to call "lifetime dresses," like Laurel Burch's things, heirlooms that you'll be happy to wear for many years and then pass on as treasures to your sons and daughters.

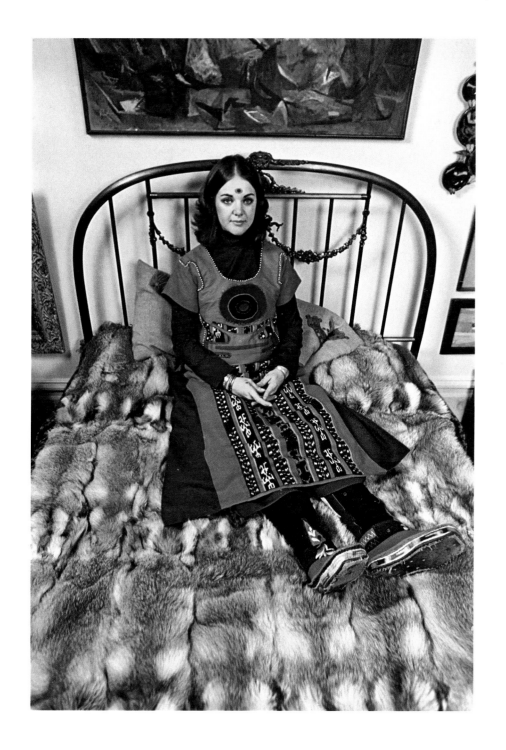

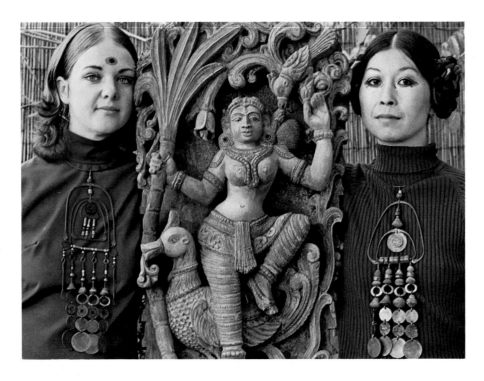

Laurel, on the left, also made the jewelry which she
and Susan wear.

Lois Smith operates a folk art shop called
The Chair House in San Francisco's
Ghirardelli Square. She patronizes cur-
rent folk artists and has a special love for
Laurel's work.

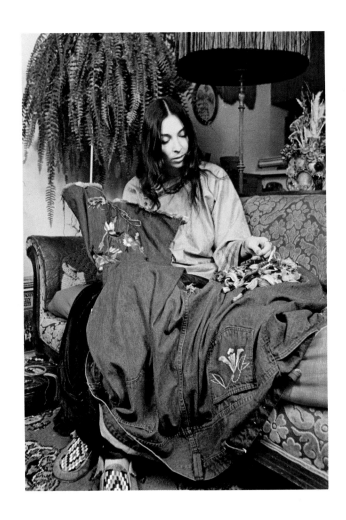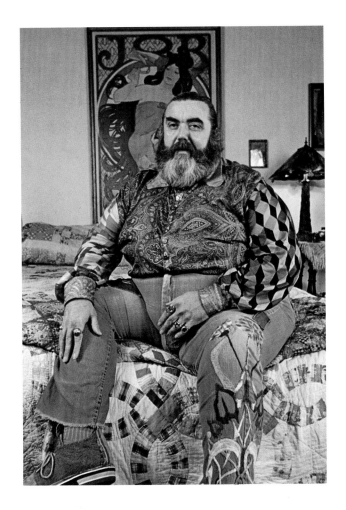

Another patron of the arts is radio personality Tom Donahue,
whose particular affection goes to the work of Linda Bacon, left.
Her embroidery on his clothing is sure to be bequeathed, too,
though perhaps no future owner will ever fill it out as expansively
as Tom has. His shoes by Apple Cobbler.

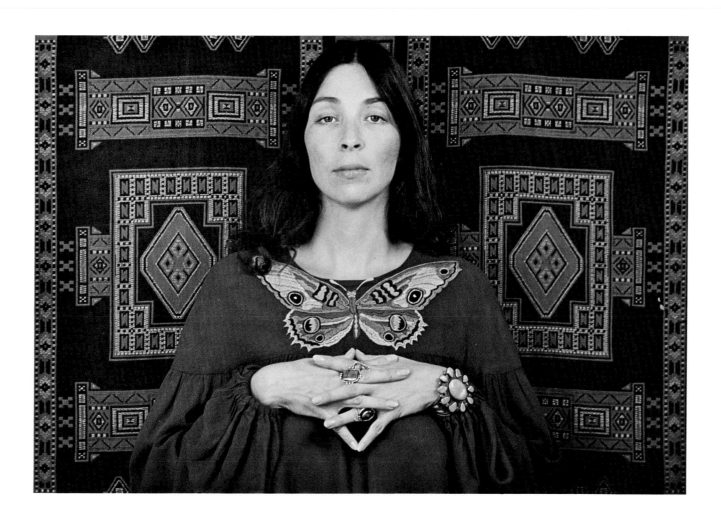

Perhaps the most spectacular single piece and story belong to Mary Ann Schildknecht. While serving a two-year jail sentence in Milan on a hashish-smuggling charge, Mary Ann was taught to embroider by the nuns. One day she decided to embroider a whole shirt, so she tore her bedsheets into pieces of the right size and started at the sun. She then worked to the left side—the sky, the trees, the forest scene, the Road to the Sun. "That's all fine and dandy," she thought, "but I need a house. It might as well be a castle for parties and . . . the hole in the other sleeve is for a transfusion if I ever need one, the peacock on the back is because we need animals, and the psychedelic sleeve because I didn't want to think."

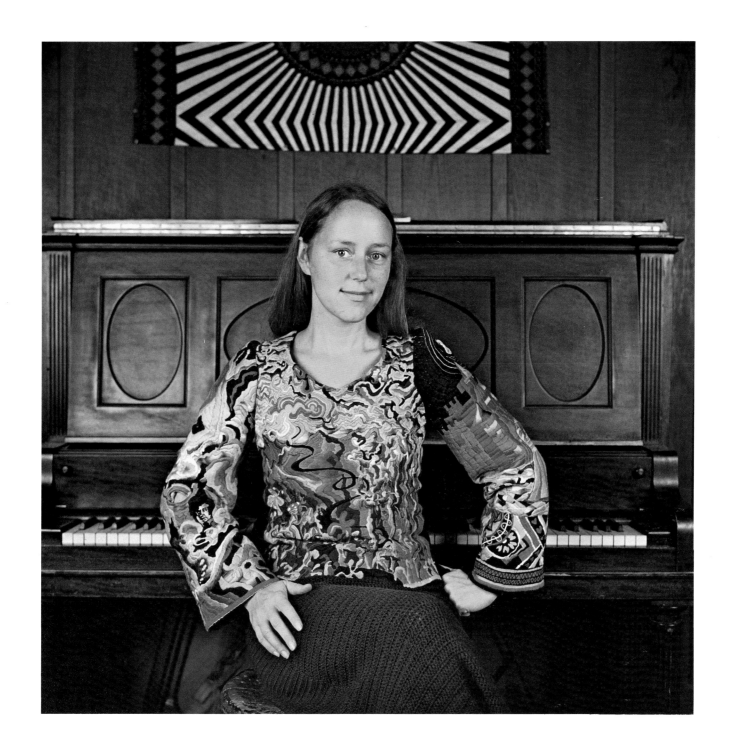

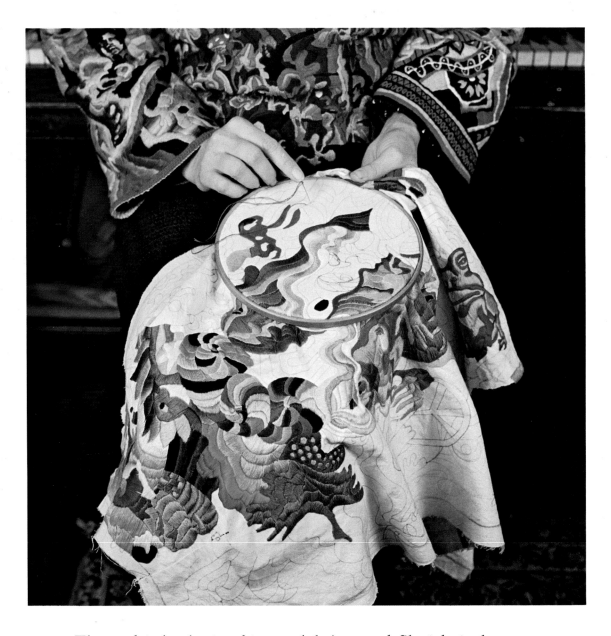

The work in her lap is a skirt panel she's started. She inks in the general outlines with felt-tip pens and fills in with DMC cottons, #8-perle, and 3 strands of 6-strand floss. I defy anyone to find a glint of bedsheets peeping through those miles of satin stitch.

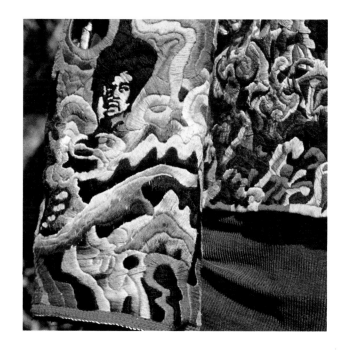

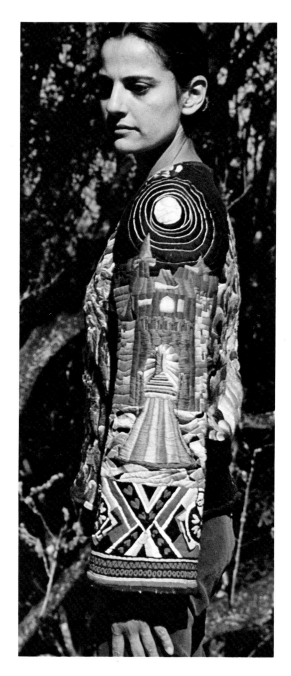

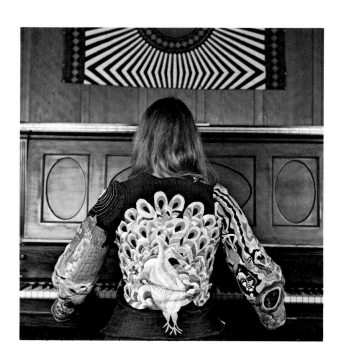

Mary Ann's friend, Renée Weir, shows the left sleeve.

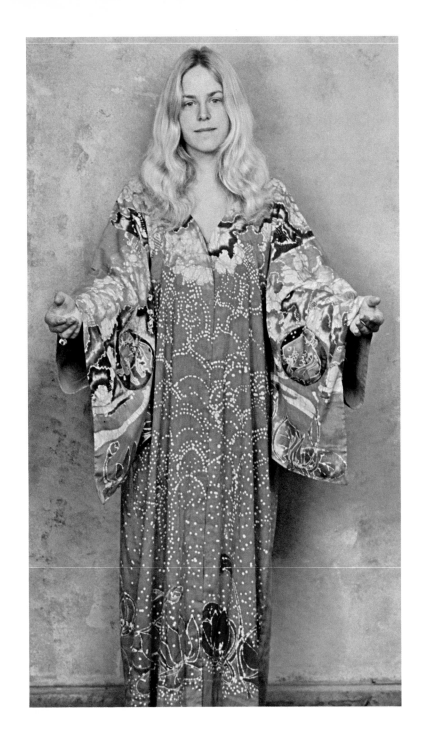

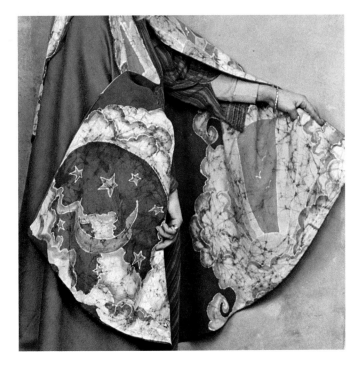

Painted and batiked clothing present real scope for textile artists. Ginny the seamstress and Elia the batik artist make an ethereal pair, modelling clothing that also fits in the lifetime hand-on-for-generations category.

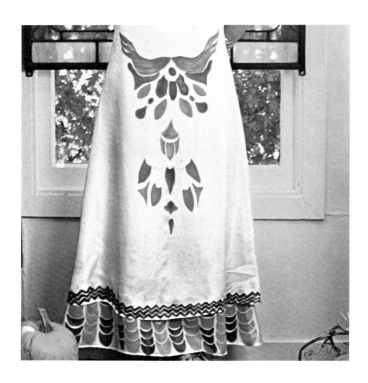

Penelope's real talent for putting together total
costumes is shown here in this hand-painted
silk dress. Apple Cobbler shoes again.

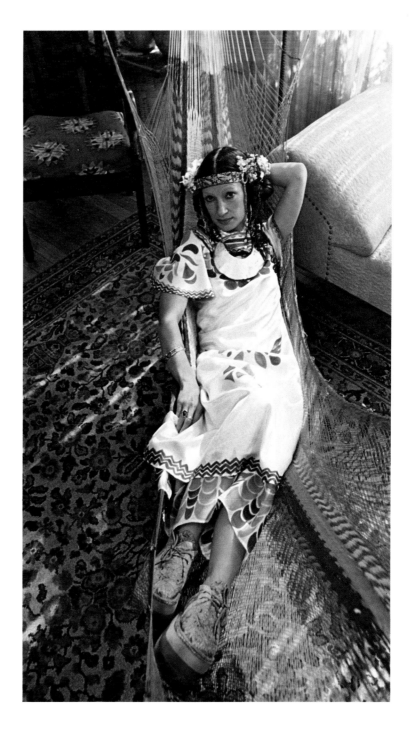

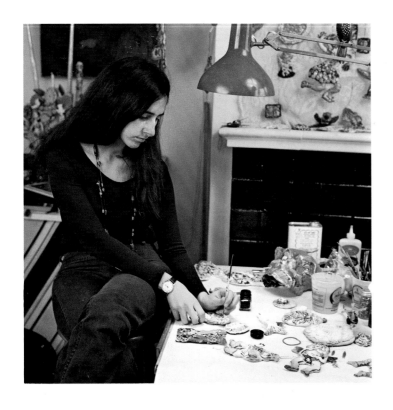

Mari Tepper Eade might have preferred to work in ceramics but has made bread dough work wonders for her. Flour and salt were the only art materials she could buy with food stamps and one thing led to another—eventually to hundred-pound lots of each.

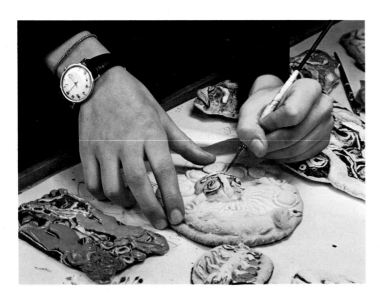

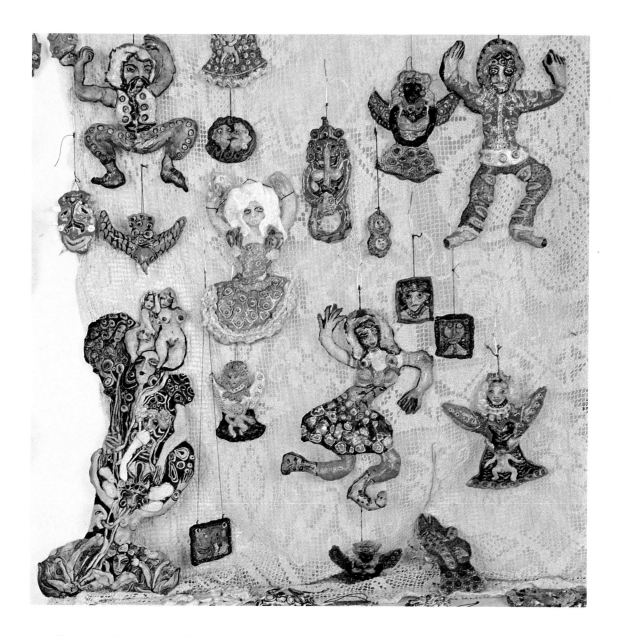

(So: mix four parts flour to one part salt, add water to get the desired consistency, sculpt away, bake in a moderate oven, paint with sugar glazes or acrylic paints and varnish over the whole thing. Try some yourself for next year's Christmas tree ornaments.) It's guaranteed to make you appreciate Mari's special touch.

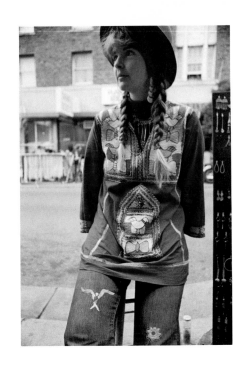

Berkeley's Telegraph Avenue crafts market, when it comes, is a genuine people's outdoor market.

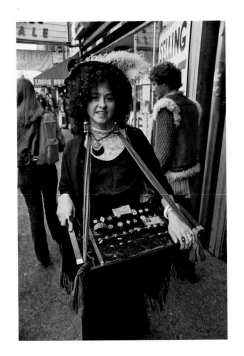

Some stuff has been brought back from travels across the borders and the seas, but much of it is home-grown.

The Bolinas Store rainbow . . .

Allen The Cosmic Messiah's One-World Bakery . . .

The Cliff House restaurant . . .

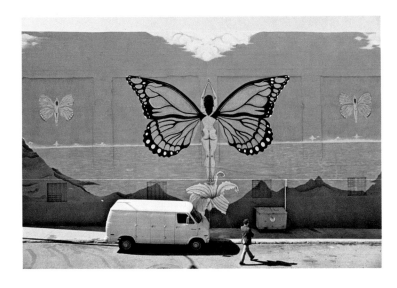

The O'Farrell Theater, an erotic movie house . . .

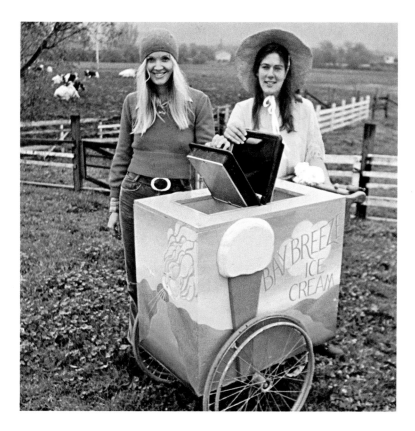

. . . and if you're lucky and if it's not the off-season
when Betsy works in the local hash-pipe factory,
you'll be able to buy, on a nice day in a country lane,
an ice cream from the Bay Breeze vending cart.

Joanna Droeger's embroidery shows what a convent upbringing can do for your needlework. Most of the pieces in this book owe little to traditional teaching, but Jo got some early formal training and an early hatred of it. She still stitches, but only for special people and occasions, especially for her in-laws, Ermine and Allen Steltzner, who wear the perfect Art Nouveau flowers and the swans on pages 96-97.

Jo's path took her through the American concentration camps for Japanese during World War II and deposited her in San Francisco's North Beach early in the fifties. She wears a smock embroidered around 1958, making it the earliest piece of its type that we found. She remembers that the first Third World piece she did was an "86" sweatshirt she did to get rid of a guy in L.A.—a "go-and-never-darken-our-doorstep-again shirt." Jo Droeger's work stands out for its perfect stitching and impeccable sense of design.

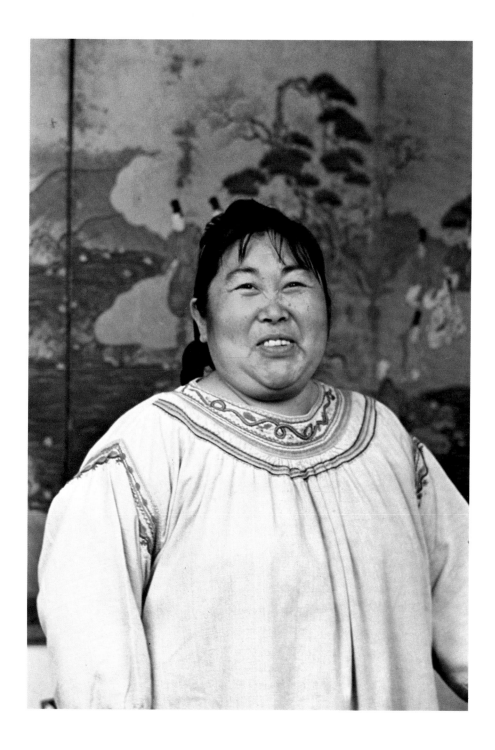

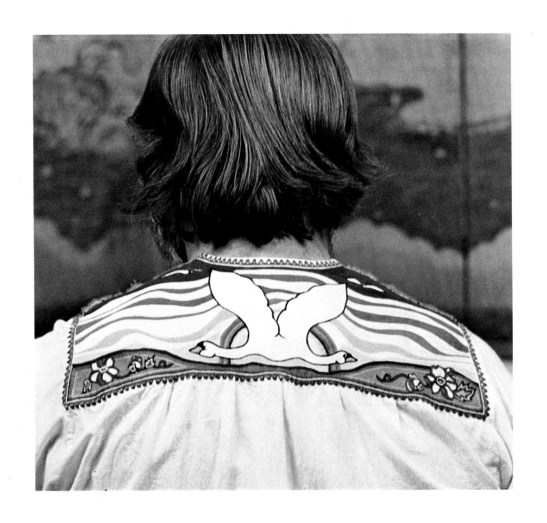

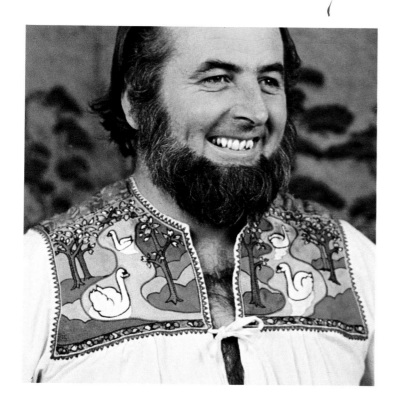

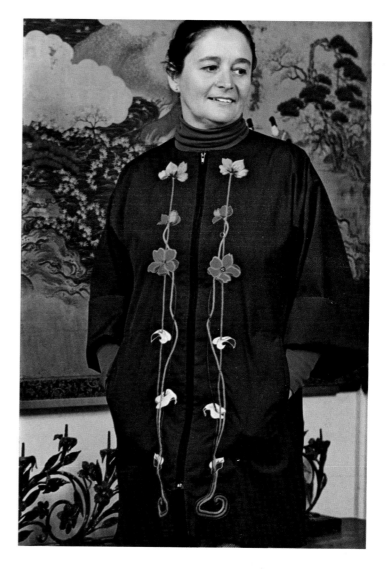

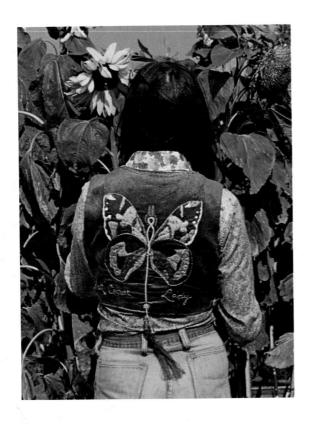

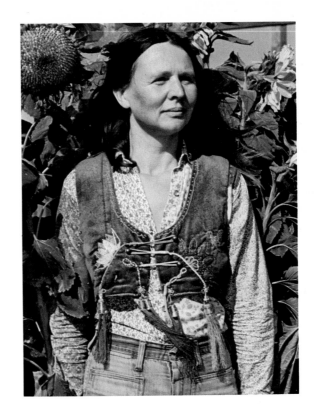

We really understood Marina and Bruce Beebe's rural domestic style when we saw how Bruce, at the end of a day, jumped out of his city traveling car and his white city architect suit and into these comfy home things. The clothes are part of the Beebes' sunflower-patch ecology. Marina's butterfly is an accurate rendition of one seen in the garden and her shirt is made from scraps of her children's dresses. (Thus the fate of people who cannot throw things away.) Bruce's bottom is the epitome of funk.

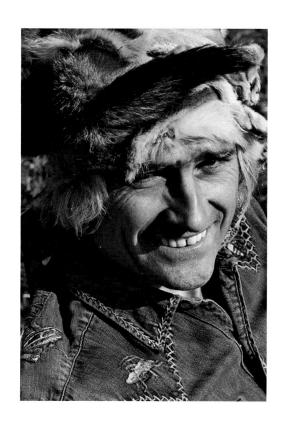

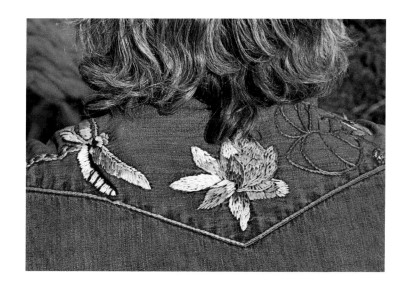

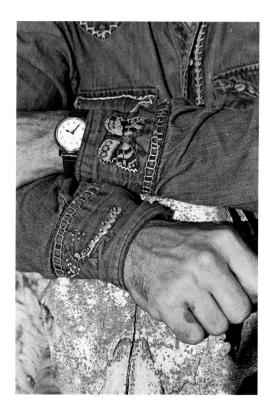

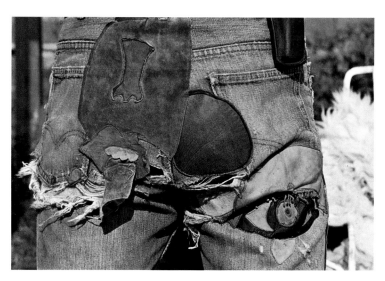

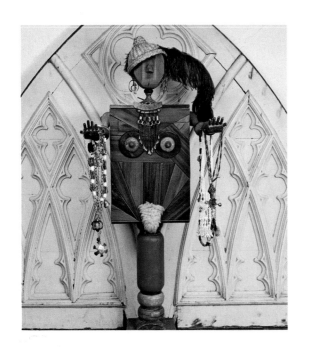
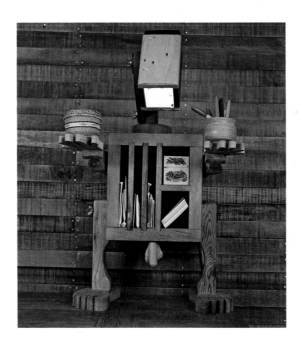

Al Garvey's presents to his wife—three devoted servants.

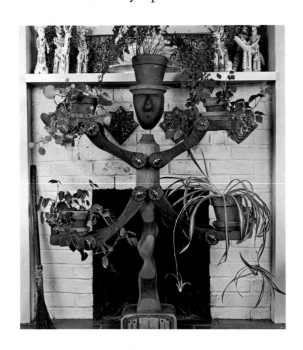

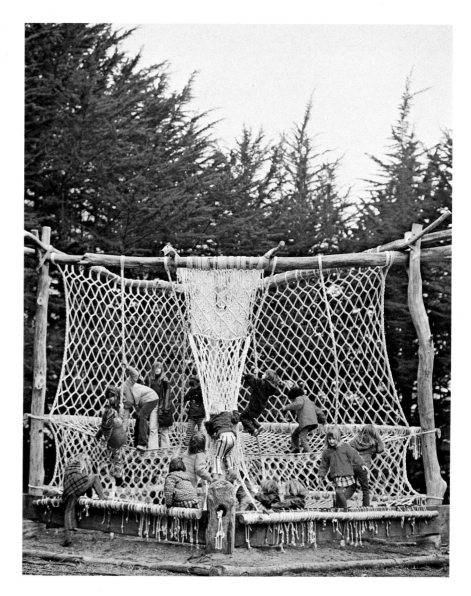

A present to the children of Bolinas—Macramé Park.

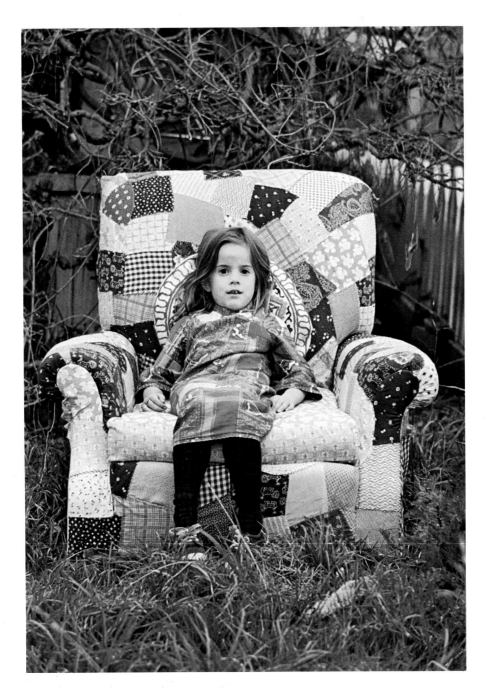

A great way to recycle a chair!

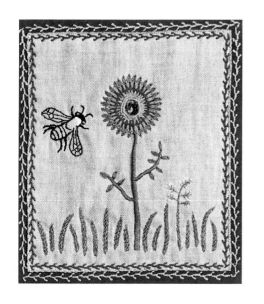

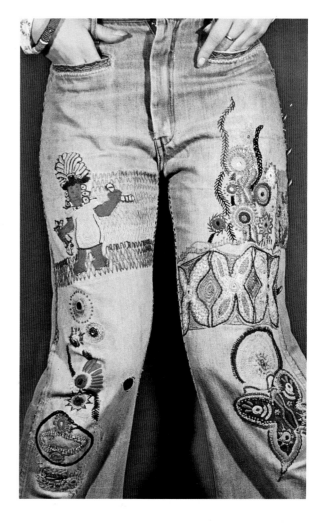

Remember the Gossip Game, where a sentence, whispered person-to-person around a circle, came out completely changed at the other end? Up on the left, Tom's knee is a "friendship patch," started by Allison, passed on to her mother, then to another friend, finished in an evening . . . a constructive version of the old game and a nice way to get some mending and talking done. Below Tom and Allison is a shirt pocket, stitched onto cloth for a wall of the kids' room after the shirt wore out. On the right you see the front of my jeans. There's a less demure view of them on page 108.

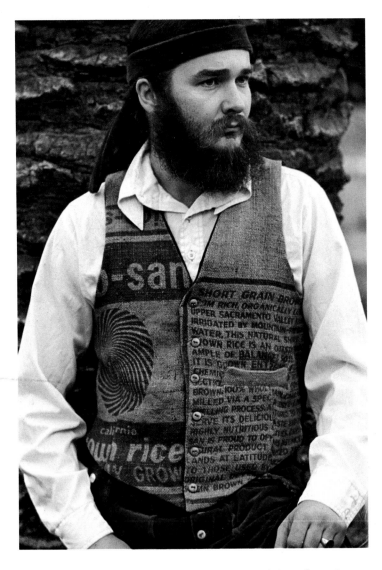

Take in a lot of brown rice as Ben and Sandra Van Meter have and you may find yourself with an extra Chico-San gunny sack . . .

Sandra's butterflies and wildflowers are California true-to-life.

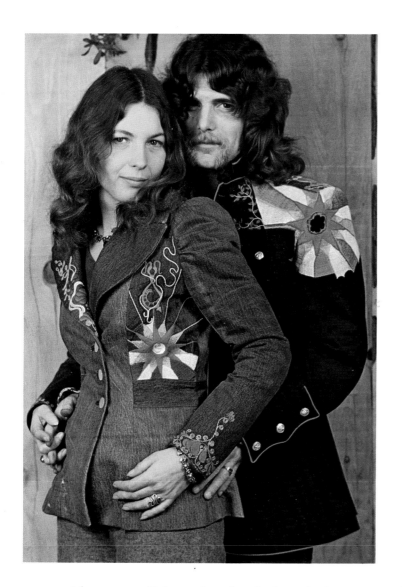 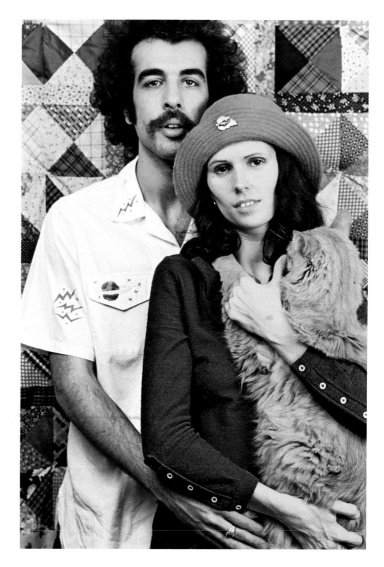

Above, a collaboration: he designed, she executed. (An interesting note on city life: the pieces we found in the city were generally more sophisticated or, as in the example on the right, more electric than those from the country. Most of the simple nature themes came from the country.)

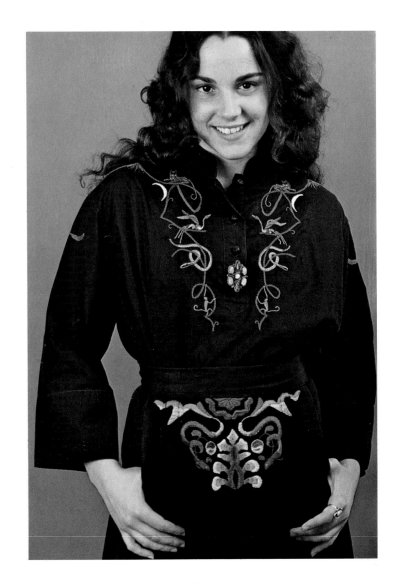
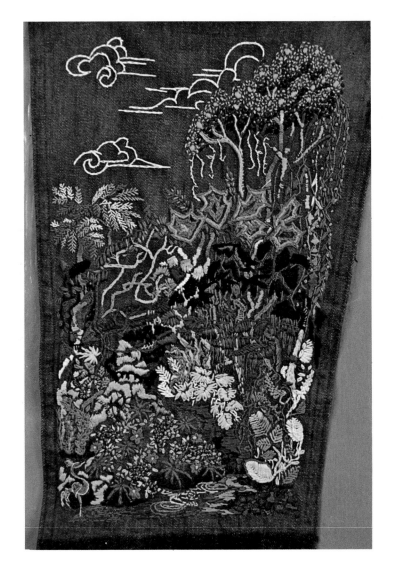

This panel from Nina Carisi's denim jacket is impressive in many ways. The color work is very strong and it reads remarkably well from a distance. Best seen from several feet away, it solves the wearer's problem of having every third stranger stop her to eyeball the clothes at a six-inch range.

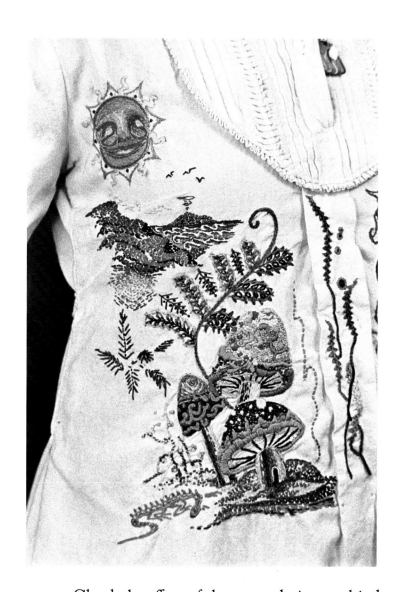
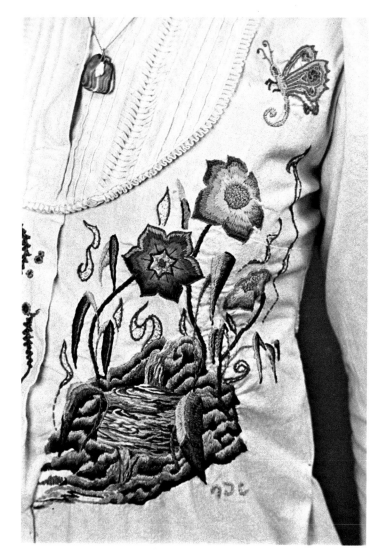

Check the effect of the water design on this dress panel close up
and then at a distance . . .

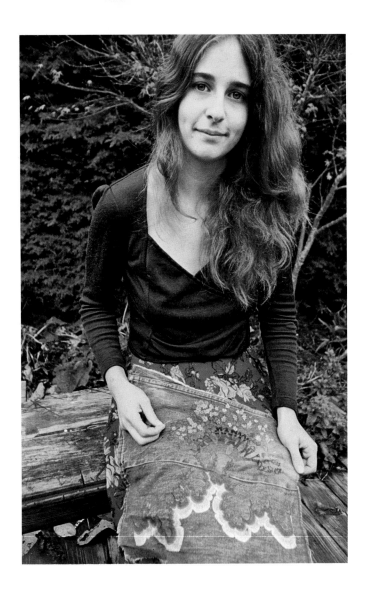

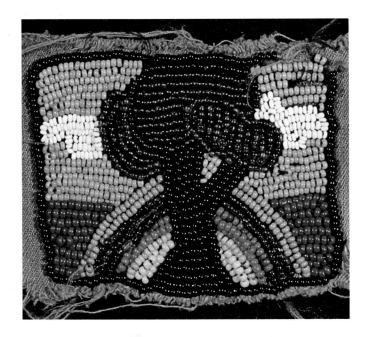

Another young one, Julie Oyle, did this beaded patch on some jeans when she was about fourteen. Compare the flames in the flaming tree design in Julie's lap with those under the phoenix on the next page.

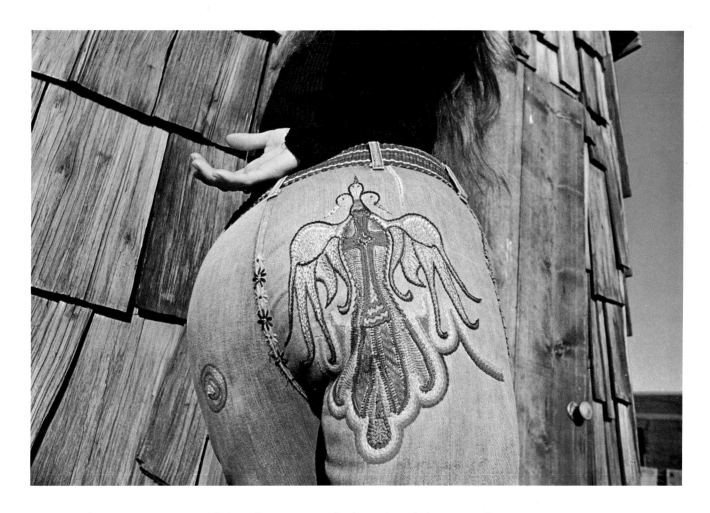

This is my version of the phoenix, with three heads because there are so many ways of looking at things. The phoenix is a mythical symbol of rebirth—the bird which burned itself into ashes on a pyre and then rose, newly-born, from its own remains.

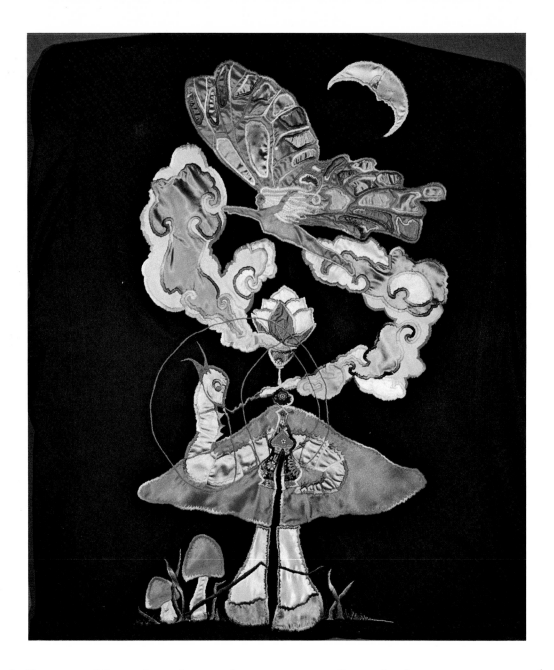

As Linda Bacon and I ruminated over the recurrence of certain themes, we came to butterflies, and she supplied the last piece of the jigsaw puzzle of this folk art phenomenon. The butterfly is the very soul of metamorphosis. Starting out as a lowly caterpillar, it becomes . . .

A LIST OF ARTISTS

First printed in May and June 1974
at Phelps-Schaefer, San Francisco
on Consolidated's Dorado Dull.
Composition: Intertype Kenntonian by Mercury Typography
and, for display, Lucian Bold by Spartan Typographers.
Color separations by Colorline International
at Scalacromo in Milan.
Binding: Lincoln and Allen in Portland, Oregon.